POSTS
FROM THE
WILD SIDE

Finding Laughter in the Middle of a Pandemic

Words and Photography by

LAUREL DAVIES

the PeppertreePress LLC
Sarasota, Florida

For information regarding permission,
call 941-922-2662 or contact us at our website:
www.peppertreepublishing.com or write to:
the Peppertree Press, LLC.
Attention: Publisher
715 N. Washington Blvd., Suite B
Sarasota, Florida 34236

ISBN: 978-1-61493-812-5

Library of Congress Number: 2022904385

Printed April 2022

THIS BOOK IS DEDICATED TO

LI'L MISS FI-FI
THE ORIGINAL WILD ONE

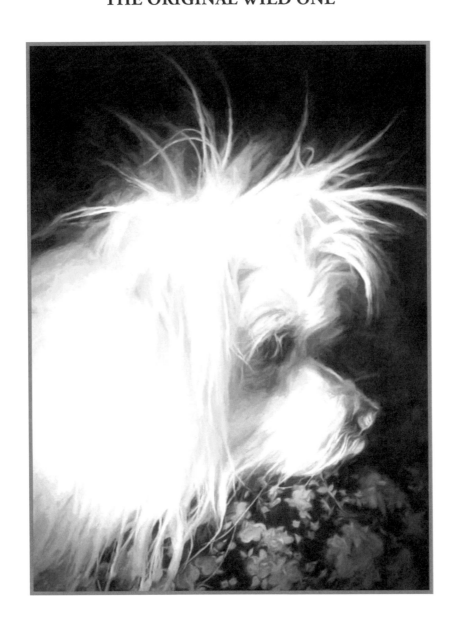

PREFACE

As a child of divorce and the daughter of a man who loved his camera, I grew up in two different households always missing one parent or another. I learned early on that no matter where I was, photos could quickly transport me to the missing parent, friends, pets, and home that held the other half of my heart in limbo until visitation was over. The good news was, I loved both houses, both families, all the myriad of pets, and the amazing landscape of both. In one house I was an only child and in the other, I was the bonus child in an already large family of ten. Life was good but my memories, as I went back and forth between the two, existed on film. The kind that, back then, had to be developed at a cost of ten to fifteen dollars a roll for 24 to 36 photos that may or may not have even turned out. The thought boggles the mind now. I remember coming home at the end of each summer and having to wait weeks to get all of my film developed because it cost so much. But you know what, it was so worth it because the photos were full of faces, smiles, adventures (and misadventures) of the people I was missing more and more by the day.

The difference between my two homes was "location, location, location." Along with the people and events I photographed, the background was what set them apart. Now my father had settled into his life in the small mountain town of Estes Park, Colorado, a tourist town just on the edge of the Rocky Mountain National Park. As an East Coast girl of suburbia, my summers on the back roads of this small mountain town were a culture shock for sure but I always quickly adapted. Kids are great that way, right? One three-hour plane ride and POOF, you're a country girl. One three-hour plane ride back and POOF, you're a city girl. No matter where I was, I seemed to be dreaming of the other home and my photos always helped to transport me back to the place and people I was missing. But, truth be told, Colorado stole my heart. To this day, if you ask me to go to my "Happy Place," Colorado is where I go in my mind. I can close my eyes and almost smell the sweet aroma of the ponderosa pine and hear the peaceful, bubbling sounds of the Big Thompson River as it rolls right through the center of town. But then there's the Southern gal, the one from the Carolinas who loves the beach, the Azaleas that bloom everywhere in the Spring, and the myriad of flowering trees, birds, and wildlife that come along with the milder weather.

With all that being said, you can just imagine the memories I have captured through the lens of my camera. My dad's photos were housed in an old suitcase for many years until photo albums became a thing. Those were great but took up so much space and Lord knows I have boxes of them filling up floor space in my garage and attic. When the world went digital, it changed everything! I remember buying Dad his first digital camera and he was amazed, to say the least. He could store four whole photos on one floppy disk! That's hysterical now, but at the time, WOW! Today, we can take all the pictures we want and share them with anyone we want without having to pay to get them developed in a lab. I can save as many as I want and don't need a single photo album. I can even store my photos in "the Cloud!" I have no clue as to where this cloud IS … but my photos are always there when I need them and that's awesome.

On the tail of some major life changes came early retirement and a new place that I now call home. The Sunshine State of Florida is fast becoming my new happy place. The flowers bloom all year round, the weather is always comfortable, and the wildlife, well, let's just say it's WILD! From the armadillo that singlehandedly aerated my yard for free last week to the alligators that have no idea what the word boundary means, I just can't get enough. My camera and I are logging some miles trying to find a new photo subject every day and as always, life is good.

Since the turn of the century, social media has given me a great opportunity to share my photos and has given flight to my passion for the great outdoors and the wildlife that call it home. I'm hoping that here and now, between the covers of this book, I can share with you more of that same passion and that maybe, just maybe, you will see something you've never seen before … or at least see it in a way that you've never seen it before.

So welcome to my world. May my imagination and cast of characters brighten your day and leave you with a smile that you can share with the world. My thought has always been to give a smile to someone you think might need it, it's almost certain you will get one in return and you just might make a difference in their day. Isn't that a wonderful thought?

Now, where is that camera?

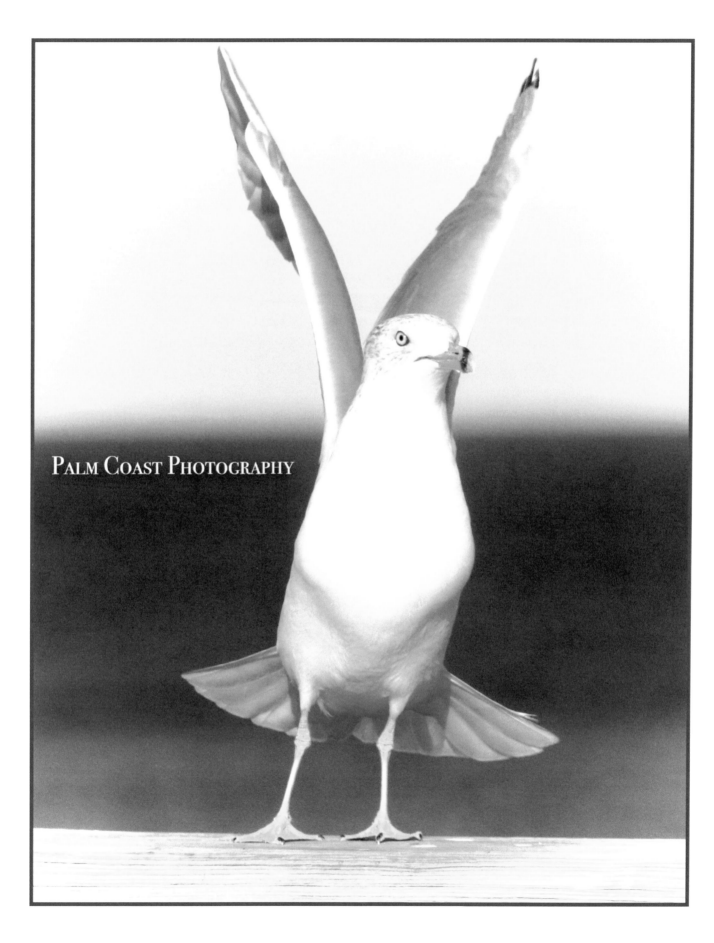

INTRODUCTION

In my whole life, I've never had trouble making friends or finding the time it takes to socialize with them. But then again, I've never had to live through a pandemic either. As they say, there's a first time for everything, right? Well, after my mother passed in 2020, I made a life-changing decision to move to Florida. I'd just turned 60 and reconnected with an old flame who seemed to have the same thoughts on dealing with a pandemic as I had. Quarantines and sheltering in place were kind of our thing even before the pandemic so we were quite comfortable with the solitude that everyone else was struggling to deal with.

One thing that was always available and a safe zone to the world during those first days was the great outdoors and I suddenly had the time and the freedom to reconnect with my love of photography. I had always enjoyed taking pictures of nature, wildlife, and the scenic views that had colored my life. Being the full-time caretaker for my mother those last few years had taken away the time and interest I had in it but after she passed and time brought on the healing, it also brought back my love of the world I could only see through the lens of my camera.

My interest in wildlife has always been to find the humorous side of the bugs, animals, and birds that I love to shoot. Finding the human side of any animal is just funny to me and that's what I'm usually looking for when I shoot. In the days when getting together with family and friends was off the to-do list for the foreseeable future, my photography took on a whole new meaning. My new friends were the animals I was shooting and the good news was ... they didn't carry Covid-19 and Social Distancing was a built-in guarantee. So, pandemic be damned, I was back in the game. I used the photos I shot as a fun and humorous way to connect with family and friends, old and new, through social media. The goal was to make them smile, maybe even laugh, when our days were so heavy with non-stop pandemic updates and political differences that were splitting friendships and families like I'd never seen before. We needed something lighter, some common thread that connected us rather than divided us. With that thought in mind and two years' worth of social media posts and photos, this book was born. I hope it brings a smile to your face and reminds you that if you look hard enough, you can find humor just about anywhere.

I've never had trouble making friends and meeting Sophie was no exception. She had just found out that she and her mate were about to have some little fluffies flapping around and she said she couldn't imagine how her life was about to change.

For the better, I told her. For the better!

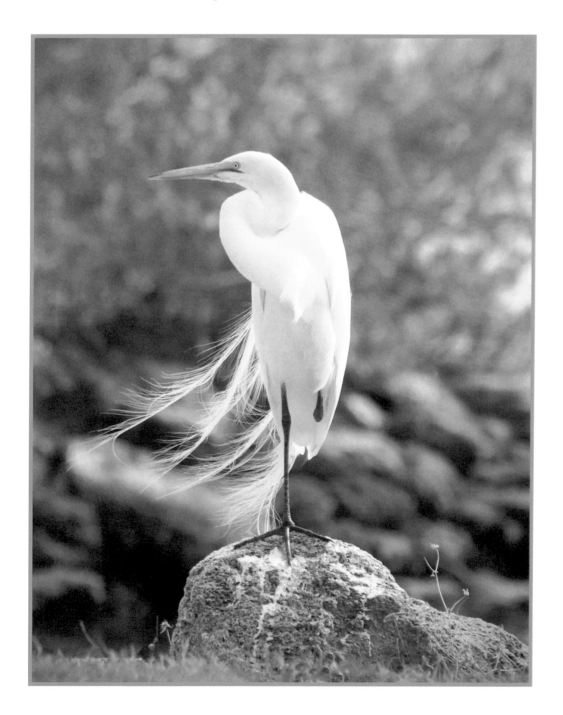

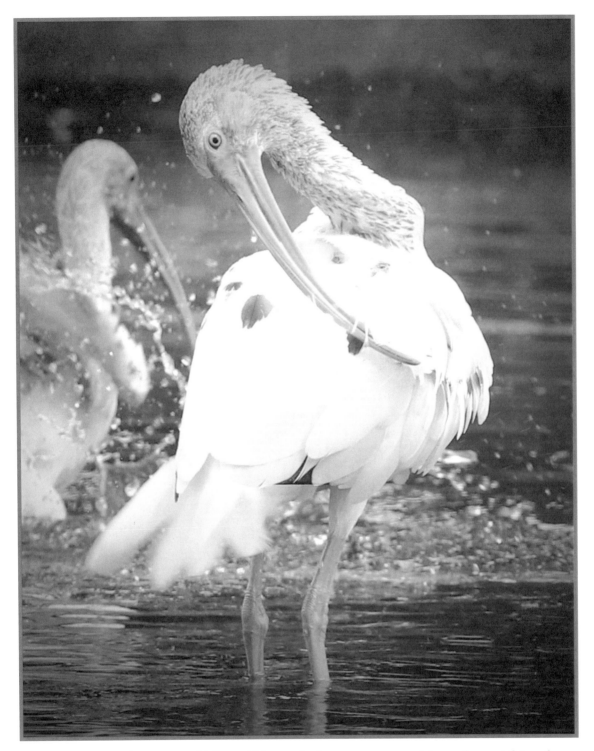

This young American White Ibis and about twenty of her closest friends
were having the time of their lives when I happened upon them.
The summer rains have turned the corner of my bank's parking lot into a
community pool for my feathered friends. All that flapping around, the
preening of feathers, water flying everywhere, what a wonderful place
for me to spend some time ... just me, the kids, and my Canon 80D.

This is a Carolina Saddlebag Dragonfly,

another willing subject captured by my lens.

I'm assuming he's a professional as he sat for a fifteen-minute session and didn't complain once about the lighting.

#nodivahere

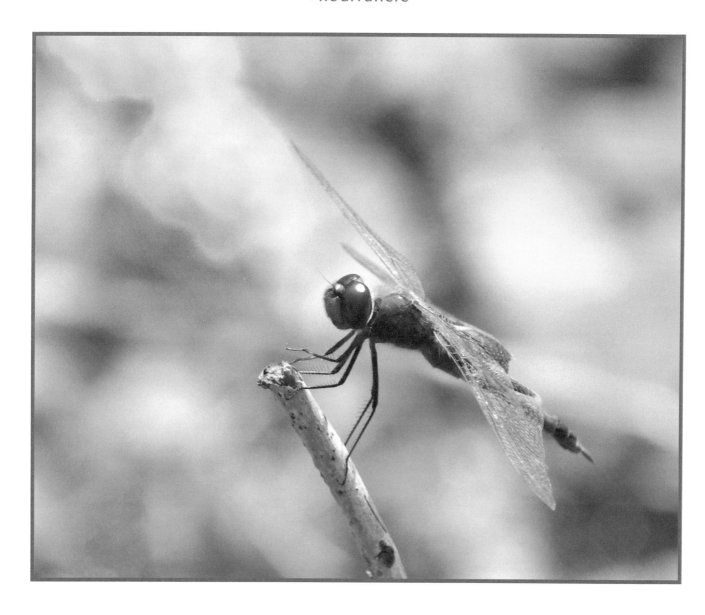

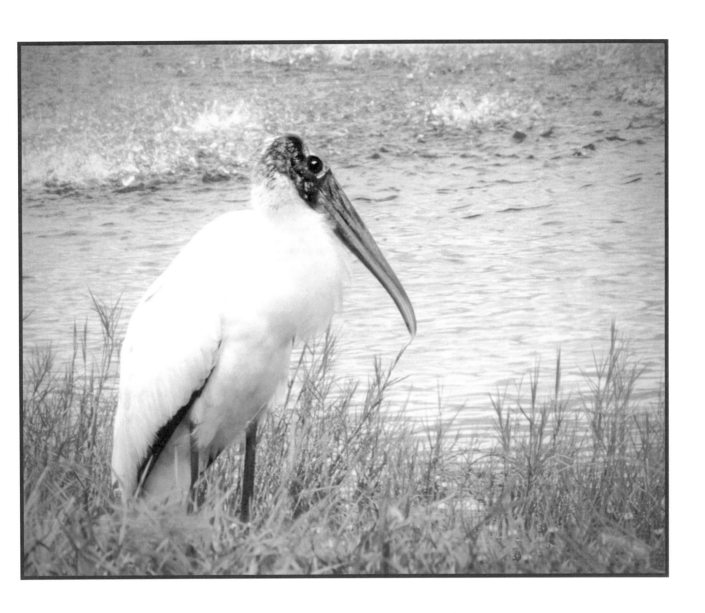

I saw this Wood Stork at the park this morning.
I asked him how business was and he said that the pandemic
had been really hard on the baby delivery business.

He is currently delivering for Uber Eats and Grubhub
to help make ends meet.

#maskchallenged

I ran into Li'l Chompie the other day and
he mentioned that he hadn't had any lunch yet.
Then he asked if I'd like to join him.
Seriously? Do I look stupid?

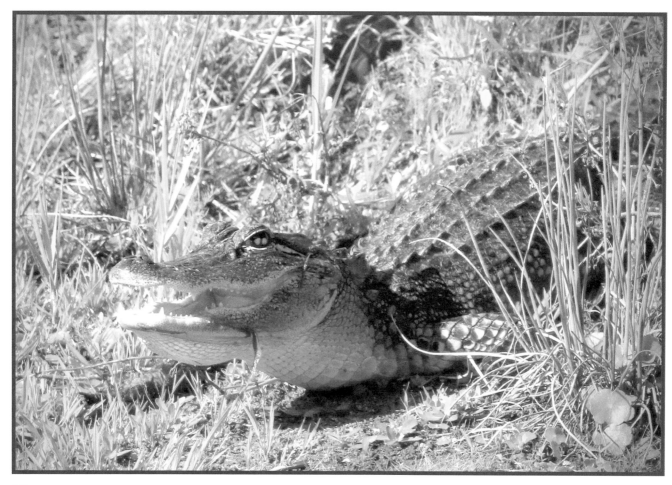

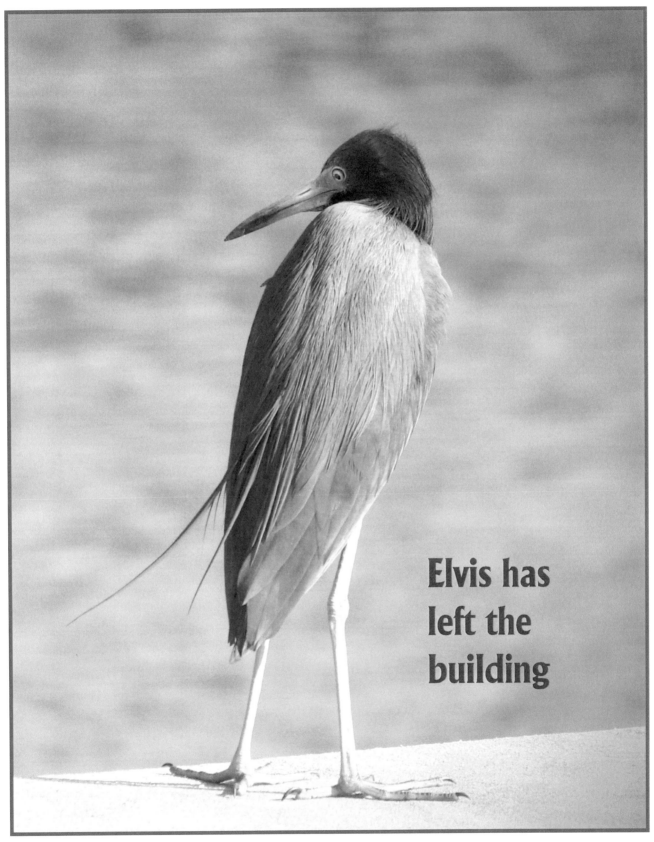

Elvis has left the building

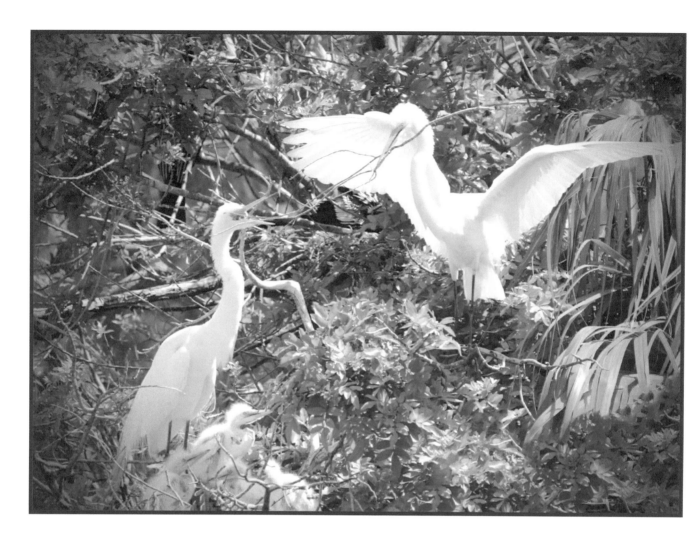

What does a family do when they have four rowdy boys who are growing bigger by the day and have enough energy among them to run a small town? You add an addition to the house, that's what!

This male Great Egret was retrieving branches from the tops of the trees and bringing them down to mama so she could weave them into the existing branches to reinforce it and make the nest bigger. The boys are getting quite active and they need more space so none of them fall out before they are ready to head off to college at the end of the summer.

#teamwork

Dragonflies are usually tough to work with but THIS guy was a dream.
I'd tell him, "Say Cheese, Burt," and he would give me the perfect smile.
The camera loved him!!!
P.S. I somehow missed the memo that Dragonflies have TEETH!

#getatoothbrushburt

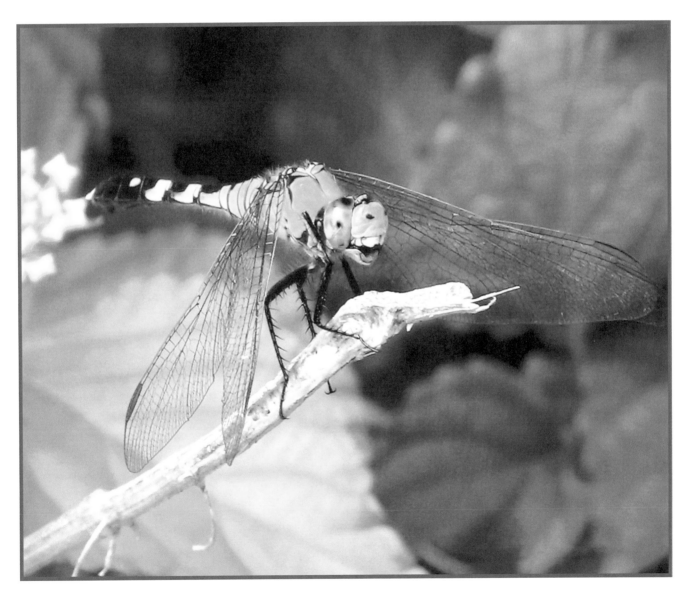

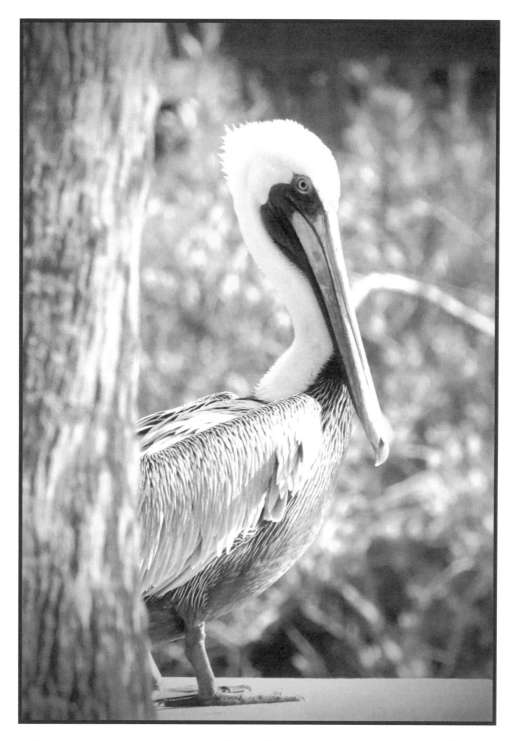

My new best friend is a Pelican named Beaker.
He followed me around the boat landing for the better part
of an hour before he realized I didn't have any fish.

He thought I was kidding when I said I was allergic to them!

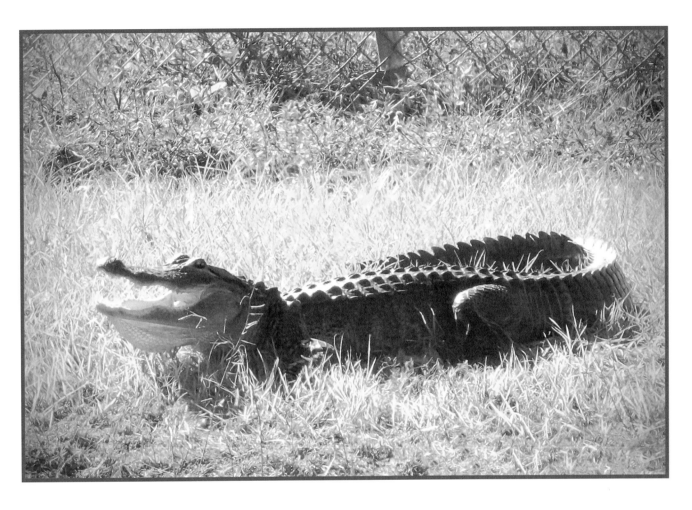

I happened upon this guy today and I have to admit,
ol' Chomp Chomp is bigger than I thought he was.
Thank goodness I was in my car!
(And yes ... I locked the door, I'm not stupid!)
I said, "You're really lucky I'm not out there
or you'd be in real trouble, Big Guy!"

He could NOT quit laughing!!!

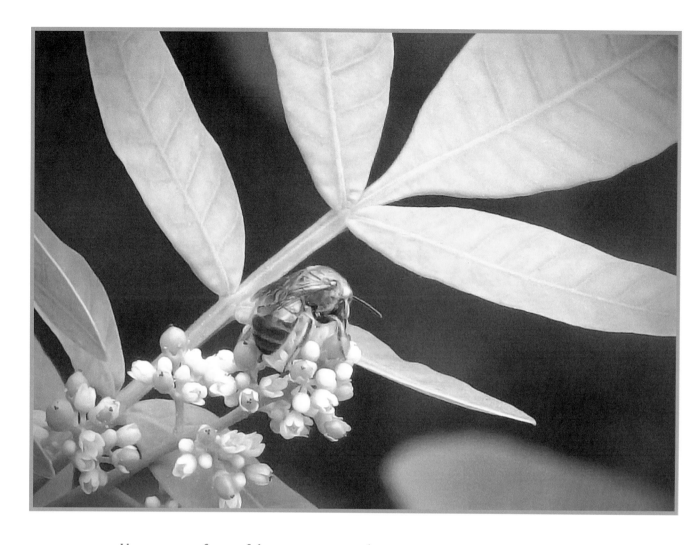

I'm not a fan of bees, wasps, hornets, or even moths.
Basically, anything that flies, can sting me, or get stuck in my hair
is off the list of my favorite things but then I saw THIS guy.
He looked just like a bee but his color was so unique!
Don't worry, I was very careful because I wasn't completely
convinced that a sting from this wild-looking thing wouldn't turn
me into the next Green Hornet.
You know, like the one in the comic books?
Come to find out, he was just a regular ol' sweat bee.

#yeahright #sweatbeewithsuperpowers

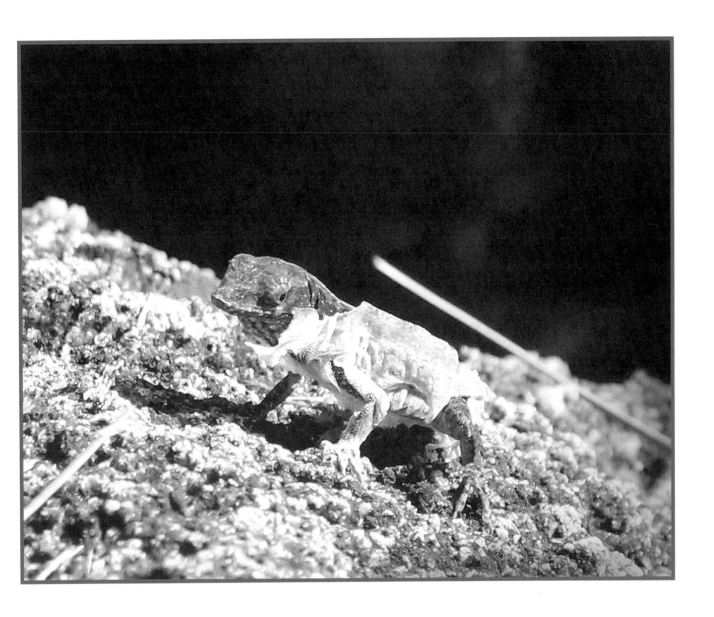

OMG ... Hulk? Is that YOU?

So get this ... I sat and watched this little guy chew,
scratch, rub, and eat his molting skin off today
and it was amazingly cool to watch.
I offered to help but he was nervous
about the close contact with the pandemic and all.

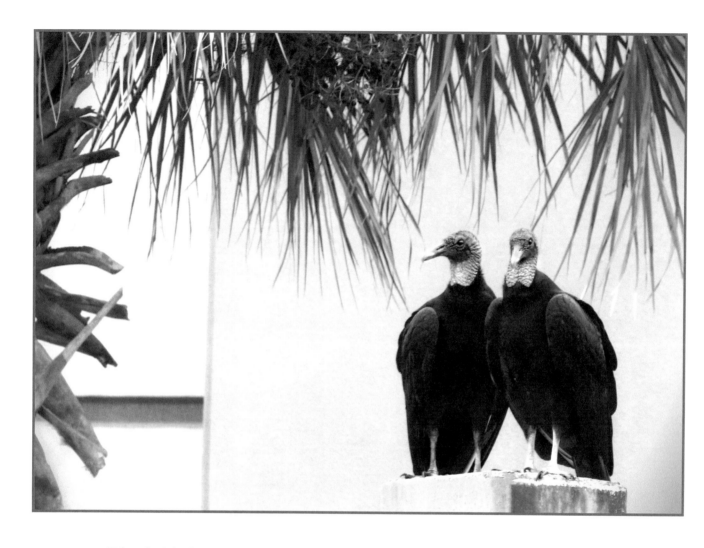

Black Vultures are pretty much everywhere down here.
I try not to read too much into that.

"Hey fellas, our Founding Fathers called
and they want their powdered wigs back!"

When I first moved here, I ran into this gorgeous pair of Sandhill Cranes. They were standing outside the movie theater near my house and I thought to myself, I am definitely living in the right place! I mean ... WOW! They were tall, slender, and had red hearts in the middle of their faces. Come to find out, they were new to the area too. They had just flown in on the

RED EYE FLIGHT!
#seewhatididthere

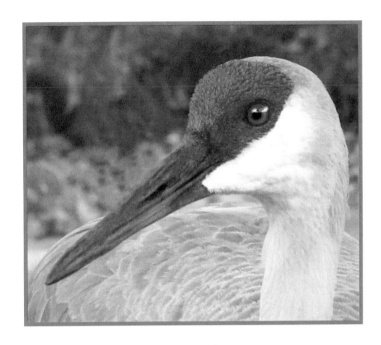

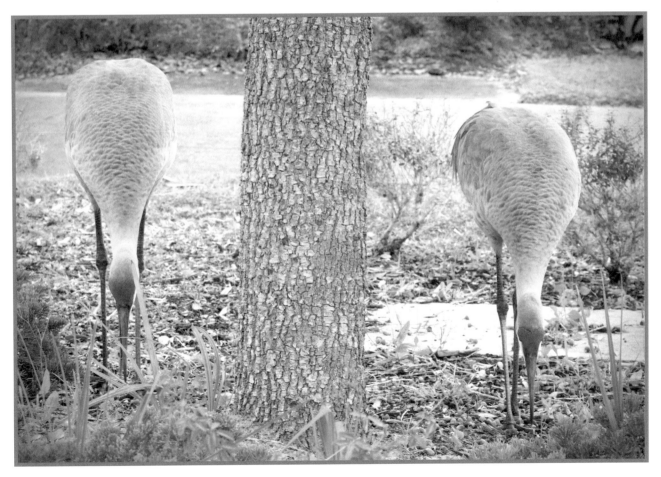

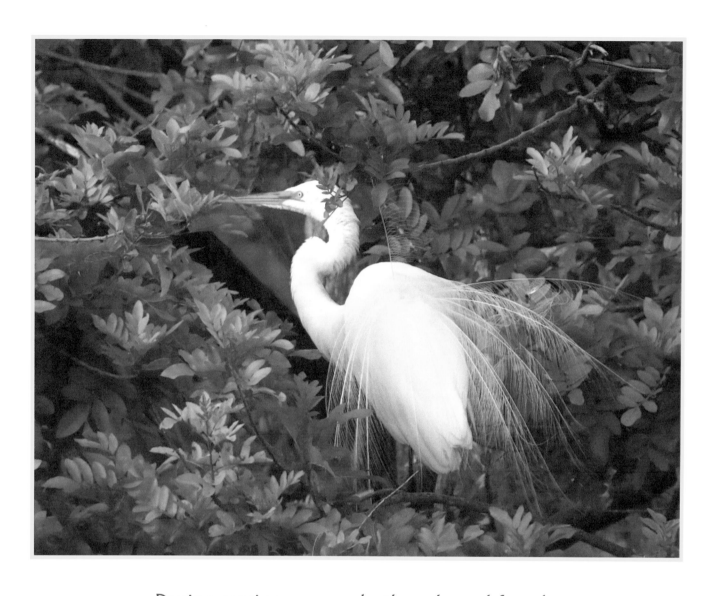

During mating season, both male and female
Great White Egrets spend a lot of time
preening & displaying their plumes.
Also, the skin between their eyes and their beak
turns a brilliant shade of green.
The only difference between the two sexes?

SIZE.

#sizeDOESmatter

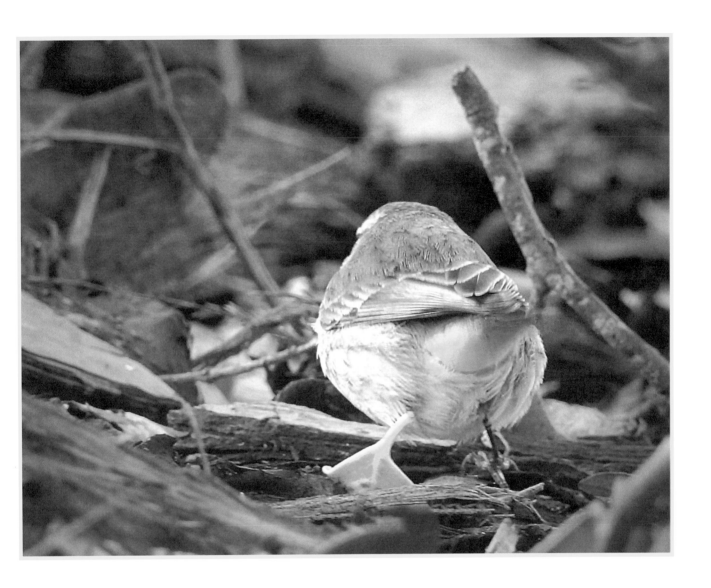

I was pretty convinced that this little tweetie pie was sporting a
prosthetic duck foot until the wind blew the leaf out from
under her and there she stood on two perfect little birdie legs.
I screamed, "IT'S A MIRACLE" and scared the
poor little thing half to death.

#dramamama

Walter was practicing how to flap his wings today
and his brother was NOT very happy about the whole thing.
Check out the look he was giving from up
under Walter's backside.

#bewarethehairyeyeball

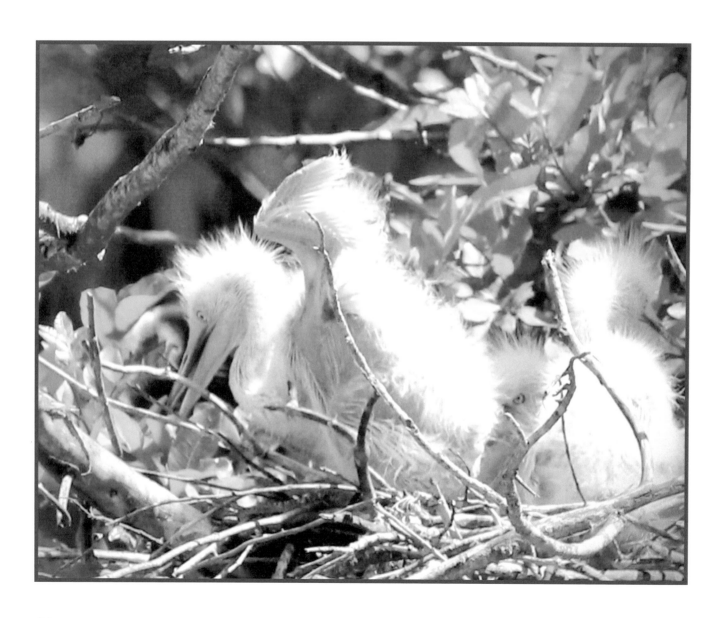

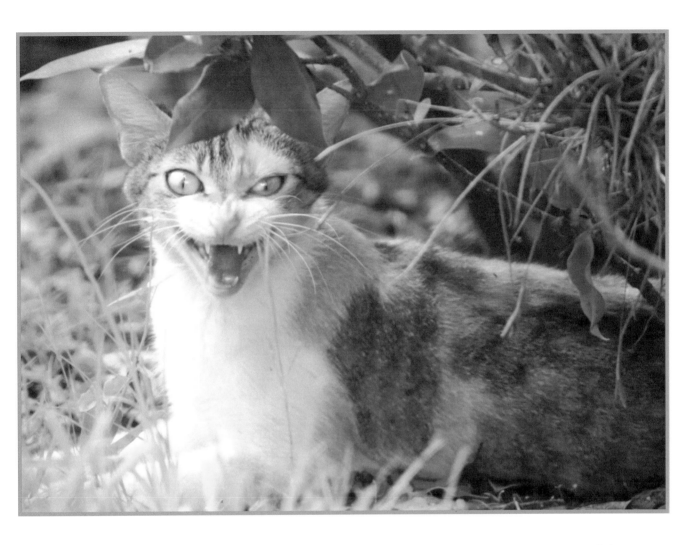

Since I'm allergic to cats, it makes all the sense in the world
that I would now be the proud owner of a feral cat, right?

She wants nothing to do with me and no contact means NO HIVES!
Now that's what we call a WIN - WIN situation!

And contrary to the photo, she really does love me.

#chillpillchattycatty

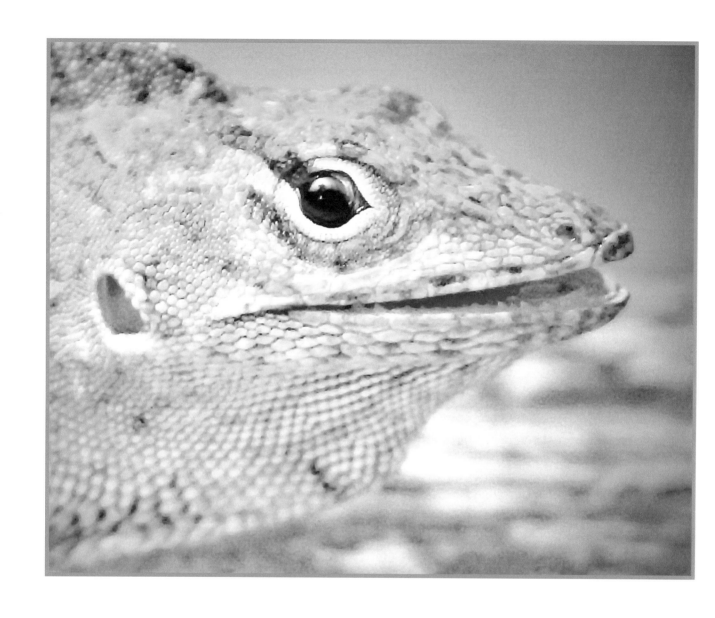

Staring Contest.
He won.

#thesunwasinmyeyes

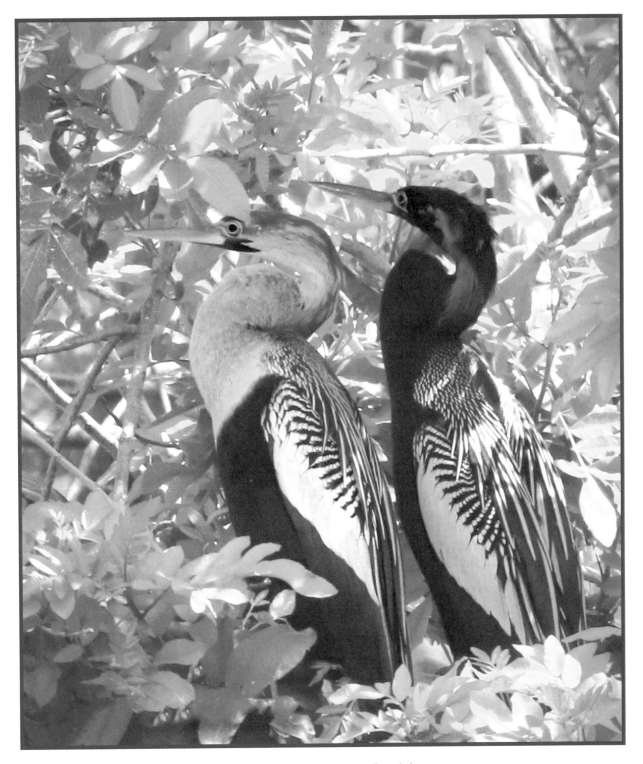

Male and Female Anhinga.

Rumor has it, they do each other's makeup each morning.

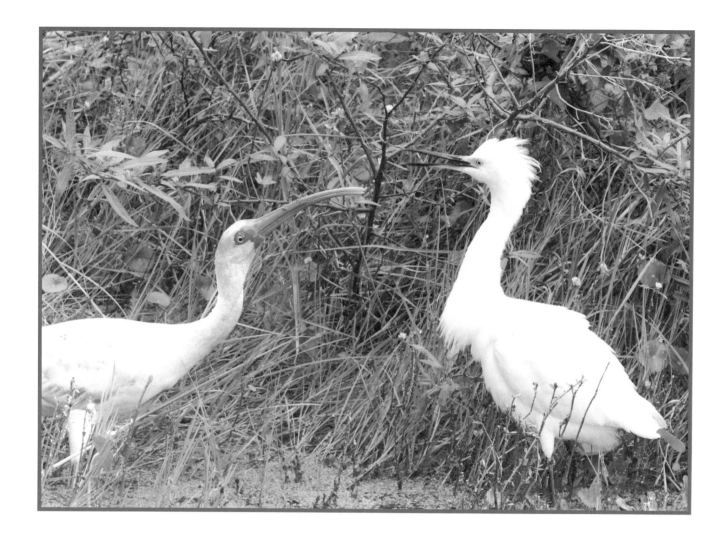

I was sitting there minding my own business, taking a few pictures,
and the next thing I know, this White Ibis and Snowy Egret are going at it.
I'm not kidding! The name-calling, the wings flapping all over the place,
and all while they kept trying to BEAK each other to pieces.

I'm like, "GUYS, GUYS ... CHILL OUT!!!"

Upon second thought, the Snowy Egret was probably a female
because as you can see, she just had to get the last word in.

#dangwomen

28

Ol' Chomp Chomp was hanging out and catching some rays when I passed him today.

To be honest, I have no idea how he gets suntan lotion on with those short arms of his but I hear he likes the stuff that smells like coconut.

#gatorproblems

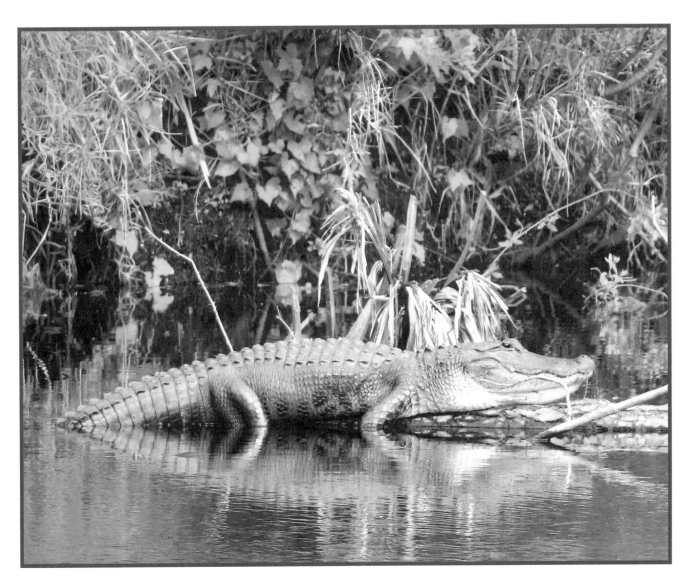

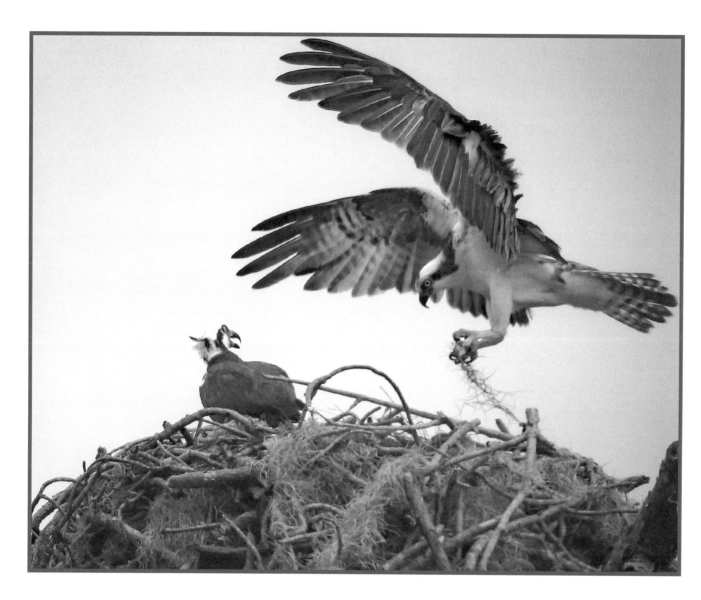

While Mom stays home and keeps watch over the nest,
Dad stays busy bringing home the bacon.
She's upset here because the hash browns and grits
have been ready for over an hour and he's late!

#whatsagrit

Mama Bird told him to stay out of the ocean
but Little Man just wouldn't listen.
You would think the last time he got swallowed whole by
that fuzzy water he would have learned his lesson.

#hardheaded

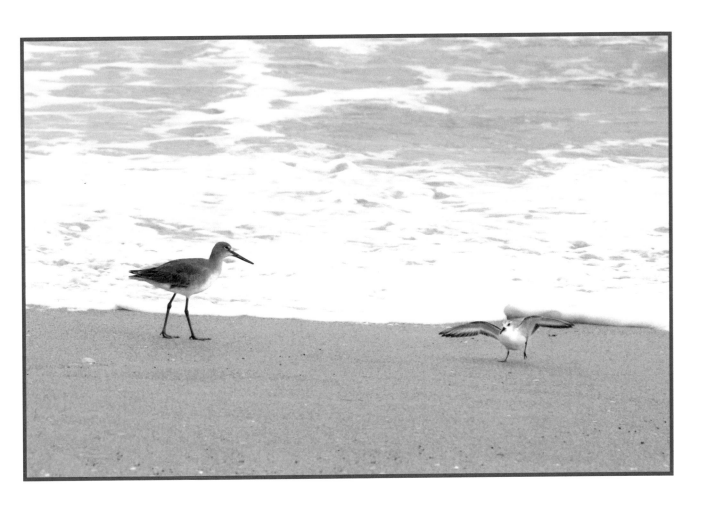

In honor of Mother's Day this year,
I posted this shot of a Mama Great Egret and her cute little family.
(even though they're not so little anymore)
Anyway, these fuzzy little angels were

EATING. HER. FACE. OFF.

Seems they're hungry and she isn't feeding them fast enough.

#hangry #donteatthefacethatfeedsya

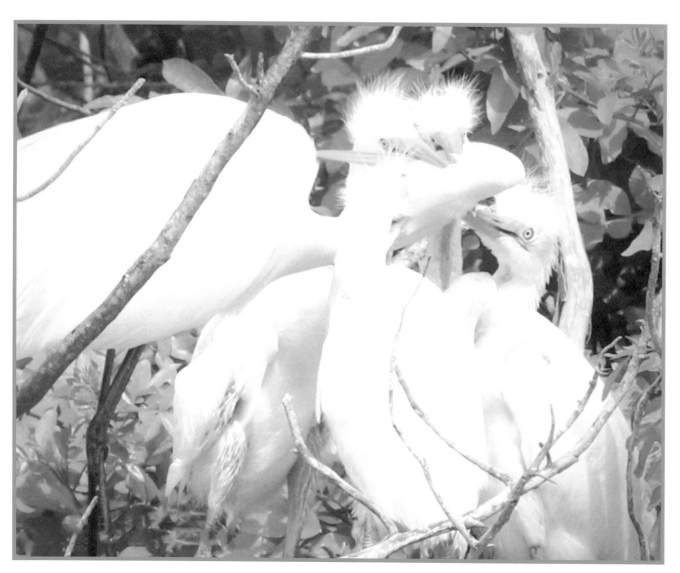

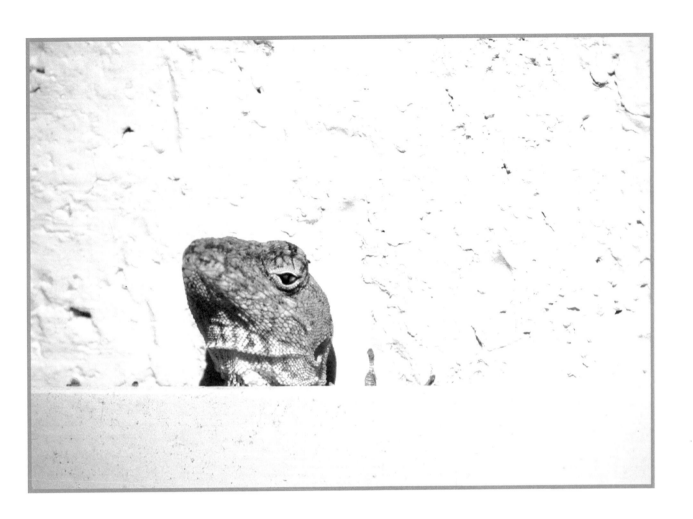

So I pulled up to the BBQ drive-thru the other day and this little fella popped up right under the window. I told him I wanted a Large Diet Soda with extra ice and then the window opened and a young lady behind it asked if I would like to order anything. I told her I'd already given my order to the little guy and she laughed.

Seems he doesn't really work there!

#jokesonme

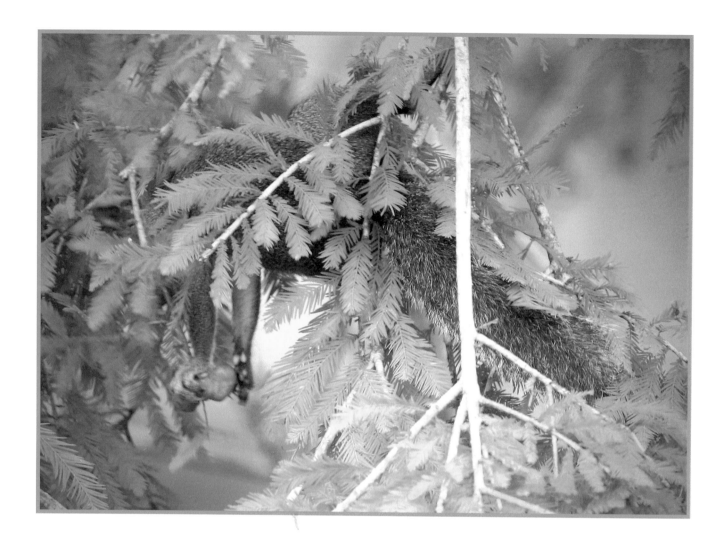

While out photographing the cypress summer seed cones today, out of nowhere sprang this feisty little bandit who stole my photo subjects one ... by ... one and ATE them!

#howrude

Anyway, I eventually had to move the whole operation to another tree to get what I needed. The thief was a fun little sidekick but I thought these cones were so pretty, I had to beat him to the next tree to get the shots I had come for.

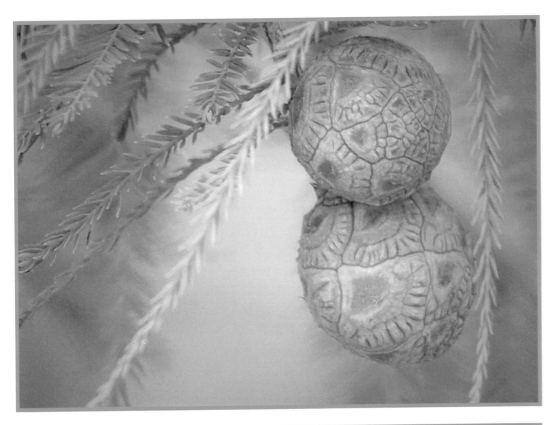

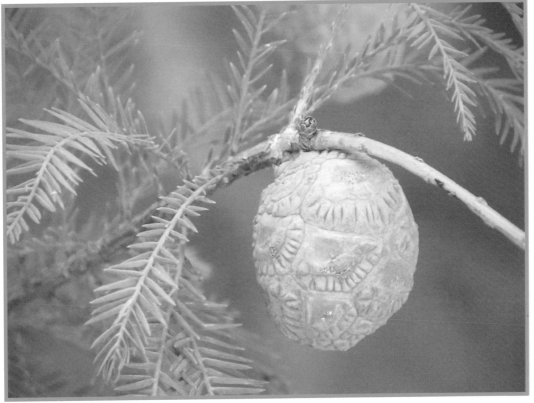

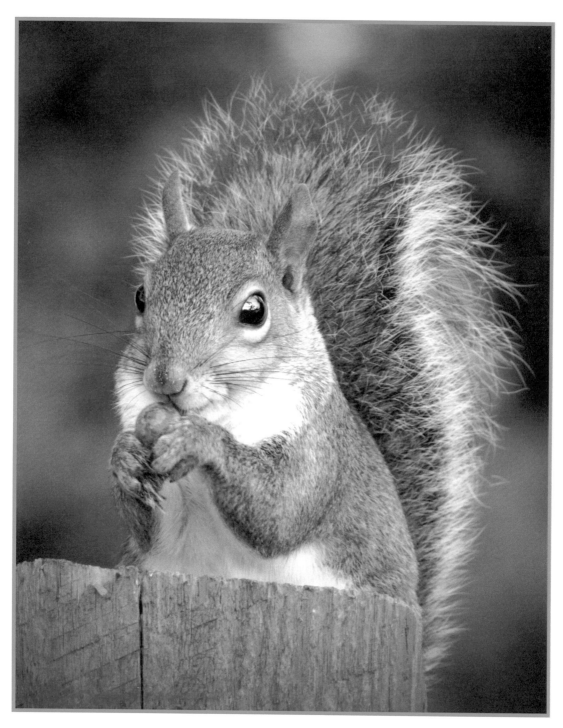

Spent some time with my little squirrel friend yesterday. He kept digging up
these acorns and coming back to the patio to share them with me.
I offered him a glass of chardonnay but he said he had quit drinking.
He must have been serious because he had a one-year chip and everything!
#AAforsquirrels

Meet the twins, Lulu and Archie.

She's a little sweetie pie and he's ... well, he's a bit of a wild one!
Here, Lulu is telling her brother to smile but Archie
did NOT want to get his picture taken and made
darn sure that everyone knew about it.

#smilearchiecrankypants

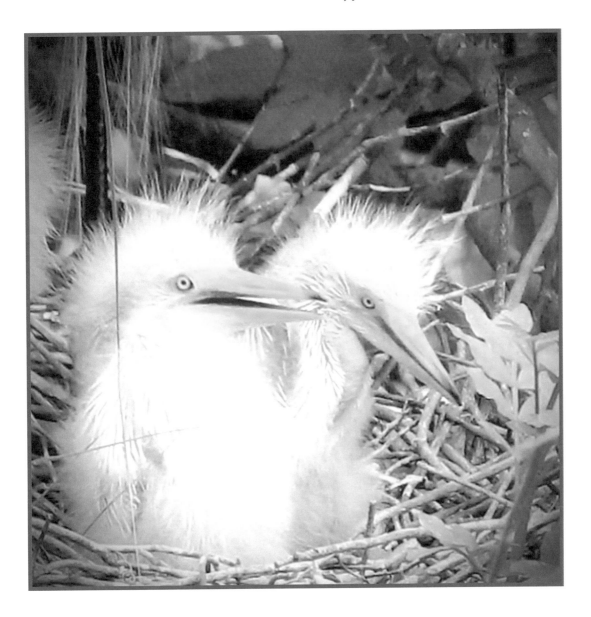

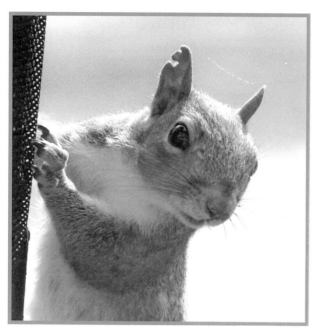

Evander Squirrely-field

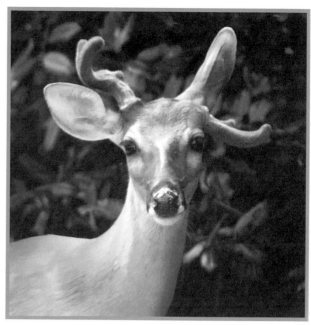

Between the ears and his antlers
I don't know WHAT is going on!

He who walks with fork-ed tail gathers more dust!

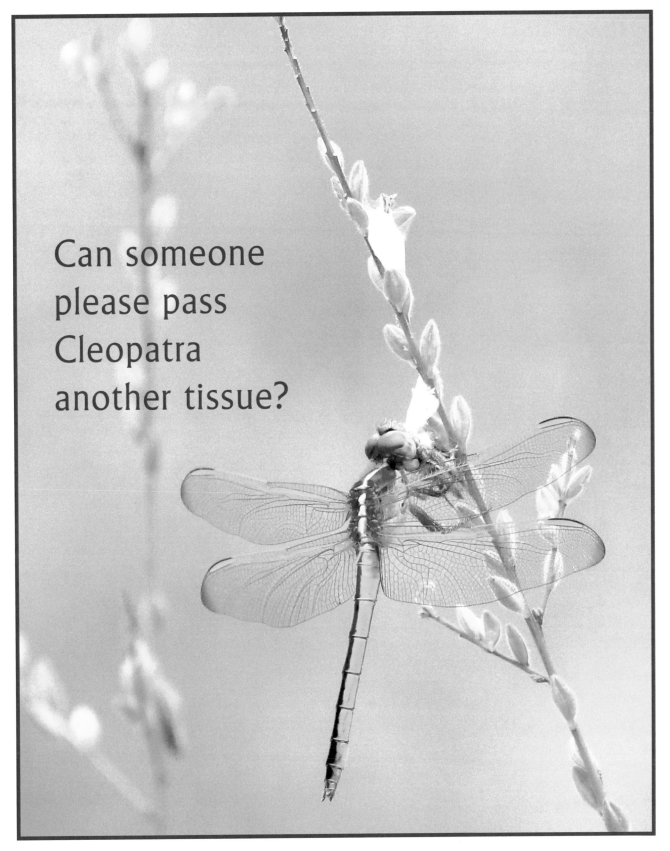

Can someone
please pass
Cleopatra
another tissue?

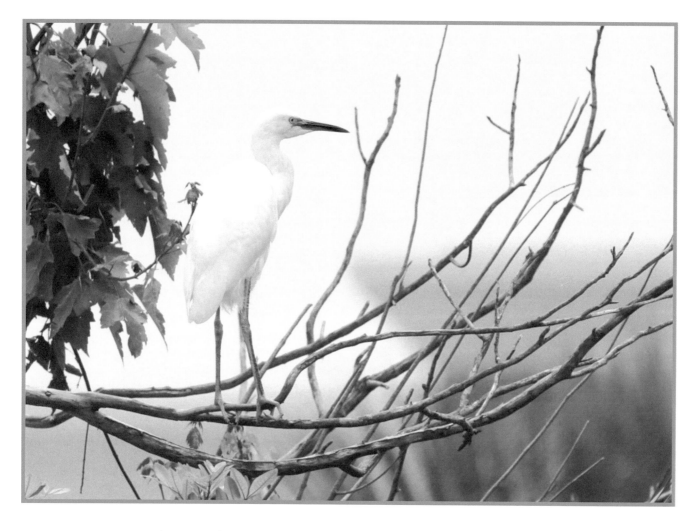

It was late and her mate wasn't home yet.
The fog was so thick and she worried something might have
happened to him. Turns out he was okay, he had just stopped
off at ... wait for it ... the local watering hole on his way back home.

She did NOT understand why I thought that was so funny!!!

#birdsgotmanproblemstoo

Morning Rush Hour

Express Lane

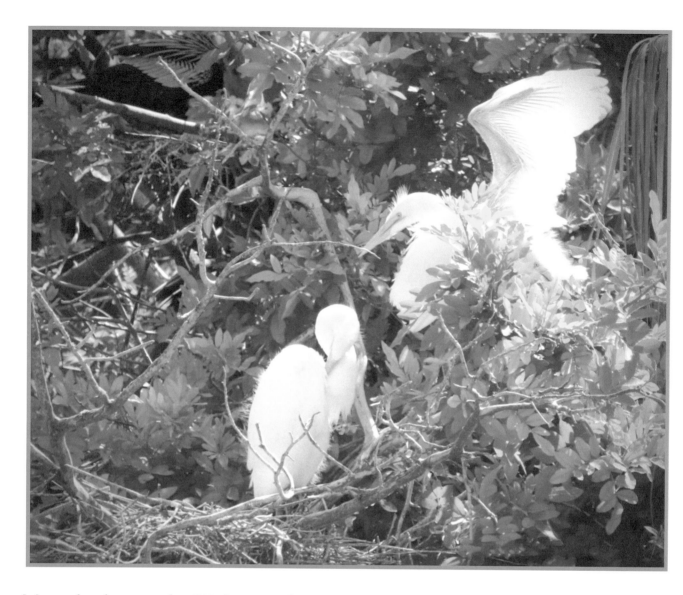

Mom had to make Walter understand that with him being the last one to leave home, she worries about him more. If he leaves the nest, even if it's only for a little bit, he has GOT to remember to leave her a note.

Poor Walter, he so hates making her worry.

#mamasboy

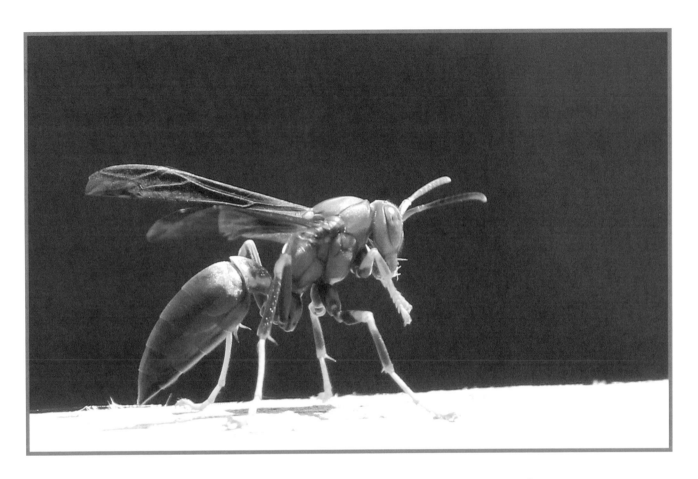

This amazing red wasp looked like it was on fire.
I hesitated to roll the window down to get this shot because
I was only a couple of feet from him but that's exactly what I did.

There are no shots of it, however, taking off, entering my vehicle,
or taking a forever nap on my floorboard.
That would just be stupid.

#noevidencenocrime

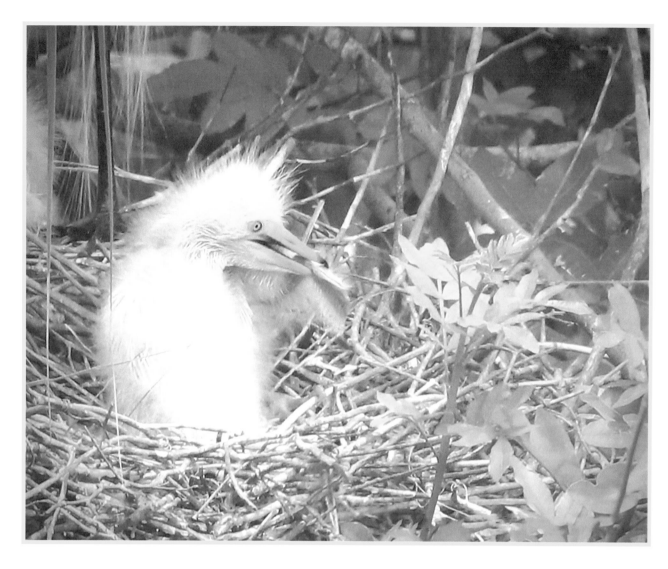

Archie heard it was BOGO Wing Night but
said he doesn't see what the big deal is.
I tried to tell him that no one wants HIS wings
but you can't tell Archie anything!

#pistachiowings

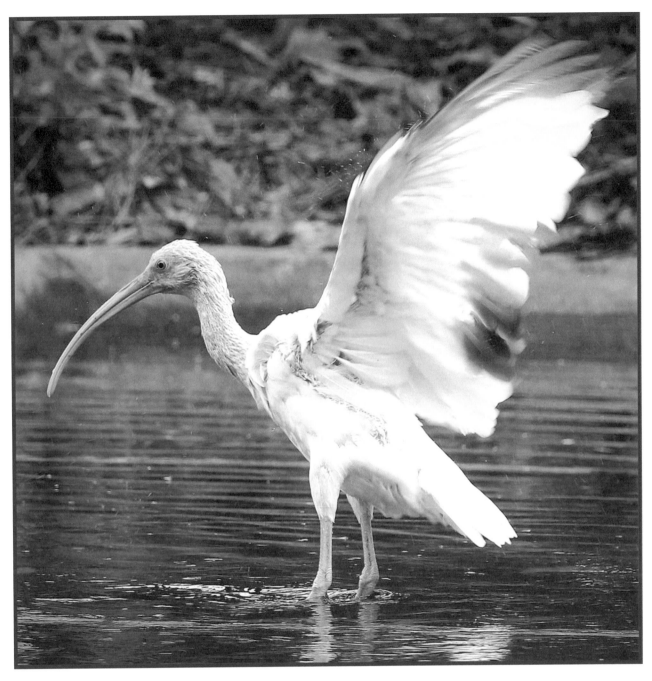

She was up to her knees in summer rain when something just didn't feel
right beneath her toes. She let out a squawk and nearly walked on water
to make her escape. I think I hurt her feelings when I laughed
out loud but seriously,

Zha Zha ... IT WAS JUST A LEAF!

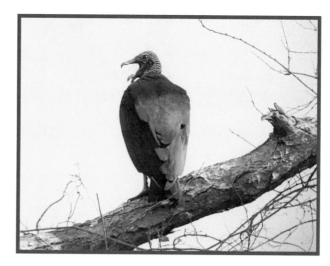

"Good morning, beautiful world!" "Yeah? What's so good about it?!"

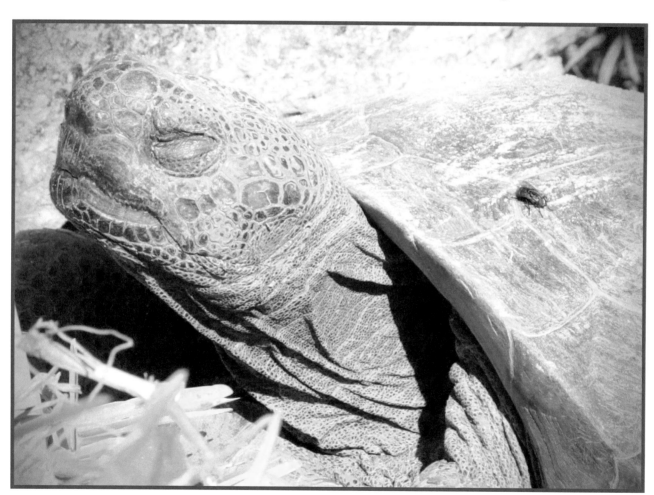

The Turtle and the Fly ... Besties for Life

This is Arthur and he is a Green Heron.

His favorite Superhero is The Green Hornet and he's an avid reader.
Unfortunately, he tends to poke holes in the pages as he turns them
so he's been banned from the local library.
Arthur is taking the news very hard.

#birdproblems #beakproofbooks

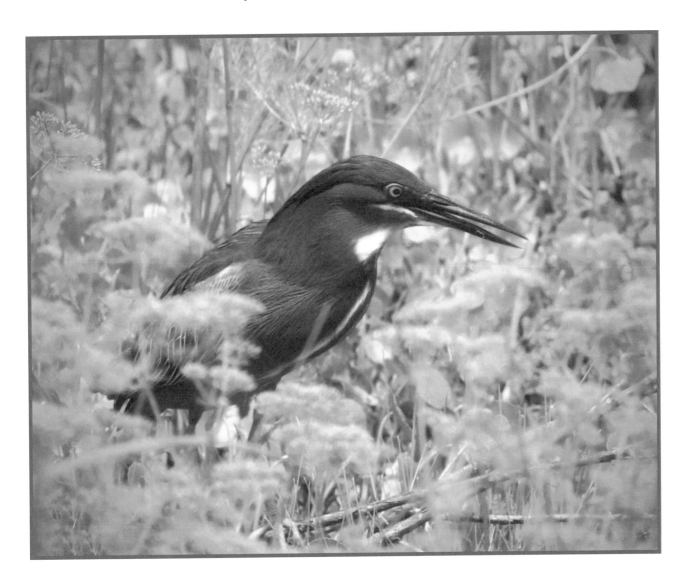

Meet Cyrano.

Cyrano is a Wood Stork and a rare find around here.

He was chillin' beside the algae-covered pond he had just been fishing in.

I asked if he was a local but he said no, he had just stopped in for a quick

bite and it was back to the skies for him.

Then he burped!

#dontbelikecyrano

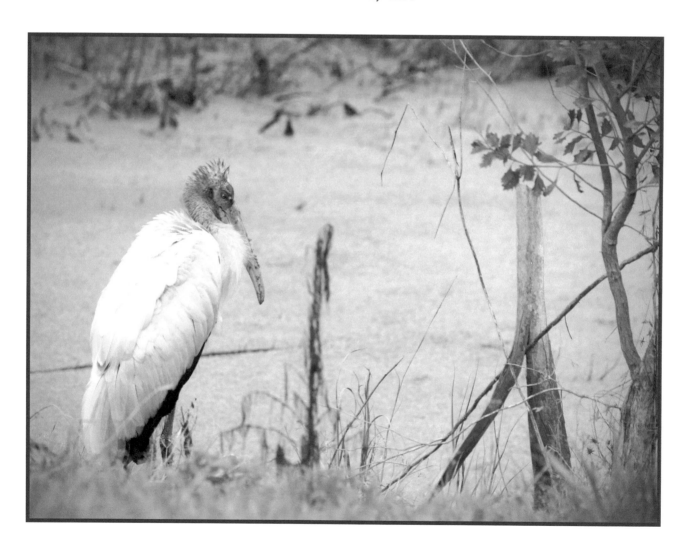

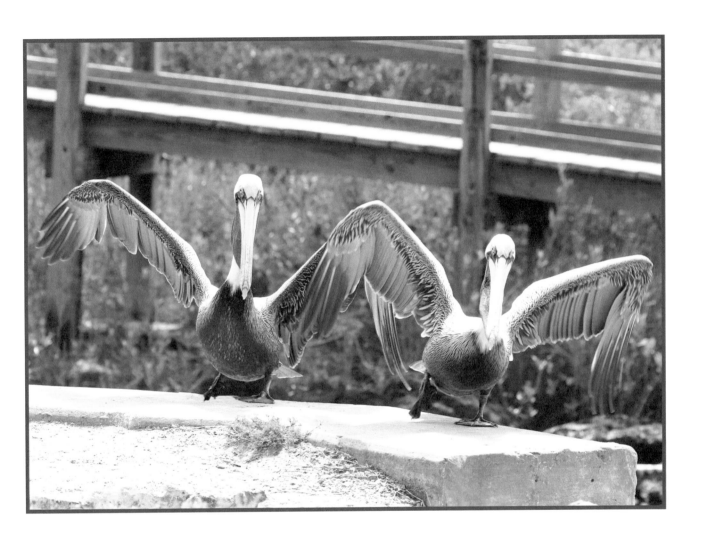

Beaker and Molly muttered as they danced,
"Heel ... Toe ... Kick Ball Change."

#pelicandancerecital2022

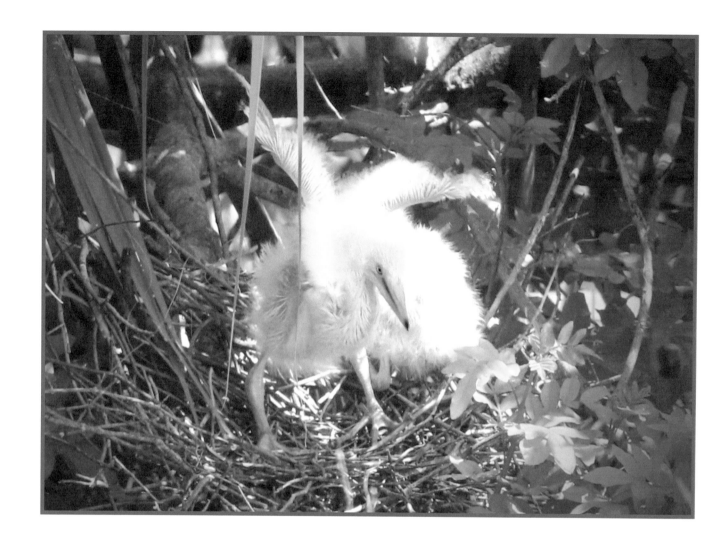

"Walter told me that one day, I'm just gonna
JUMP UP - and FLLLYYYY - right outta here!"
(Lulu couldn't watch.)
"You'll see, Lulu, you'll see!"

"I sorry, Lulu, I din't meem t' scare you."

(After almost falling out of the nest,
Archie felt bad for scaring his little sister.)

#poorlulu

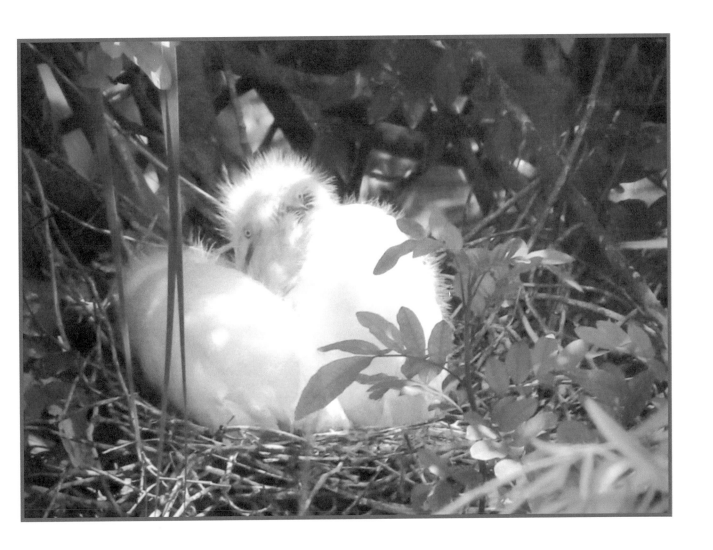

This pretty thing was perched
outside the salon.
The girl who was doing my
nails said she was next
on her schedule and that, as
usual, she'd arrived early.

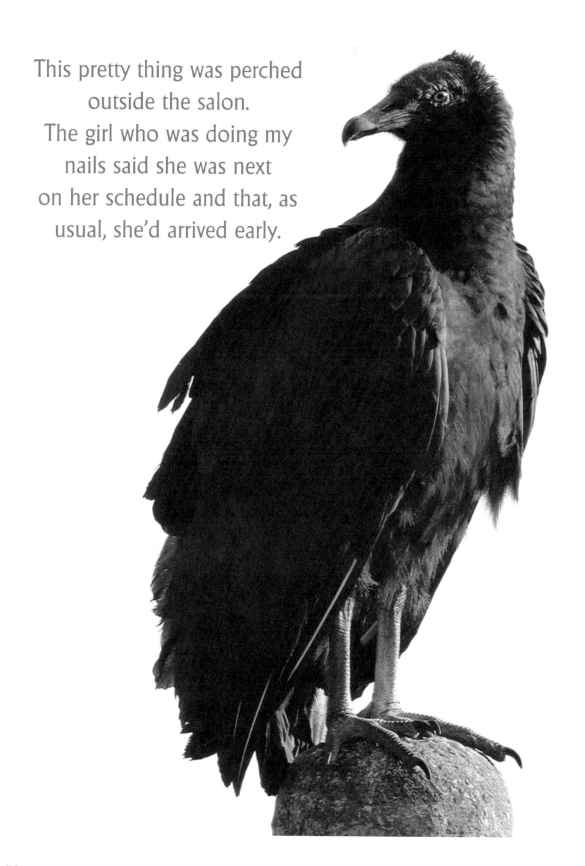

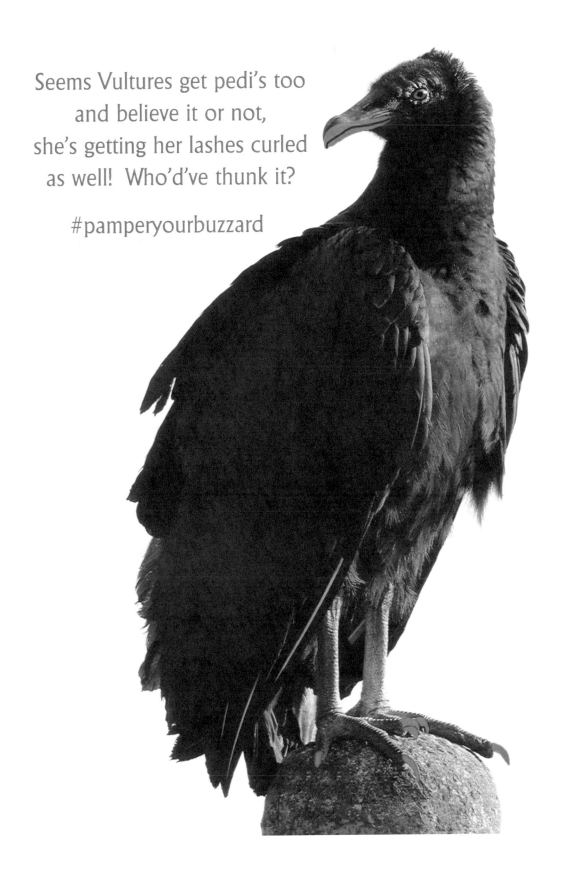

Seems Vultures get pedi's too
and believe it or not,
she's getting her lashes curled
as well! Who'd've thunk it?

#pamperyourbuzzard

Teddy
the Soft Shelled Turtle

Is this a joke?
Because if not ...
God really does have a
sense of humor!

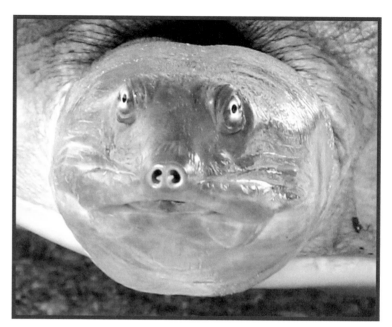

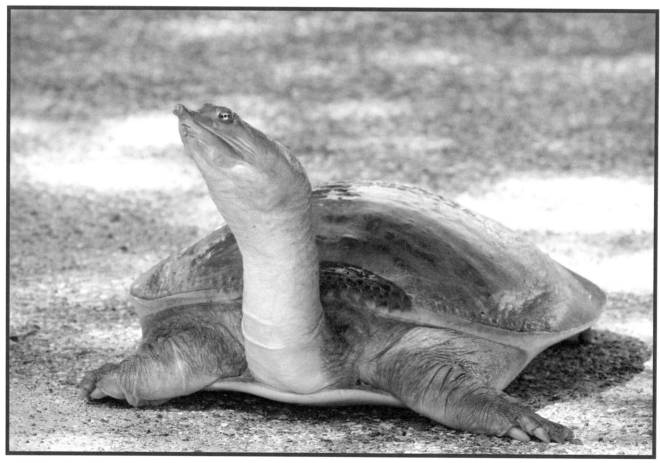

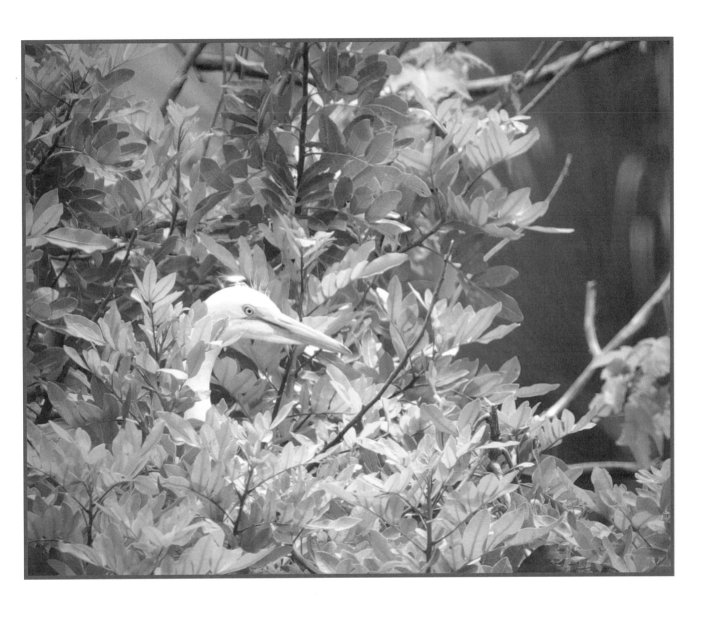

Walter, is that you?
The storm is over, buddy,
you can come out now.

#walterneedsathundershirt

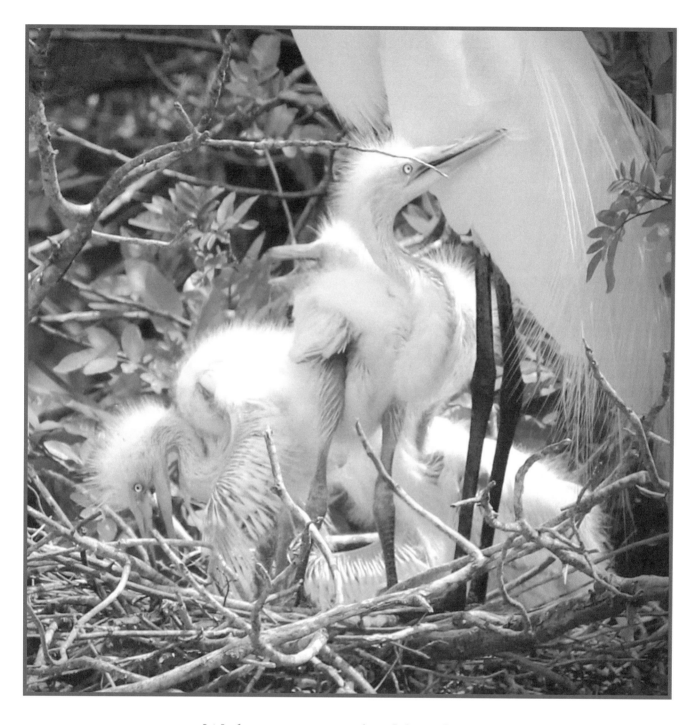

Walter is proud of his legs.
They're getting so big and strong!

I think he looks like a fuzzy pistachio!

This is the story of my sweet little Chatty Catty ... and the five sweet kittens born to this feral cat that attached itself to me before I even knew it existed. I met Chatty Catty and the kittens when I was leaving out one day. When I got home that night I noticed Mama only had four kittens. (don't ask)

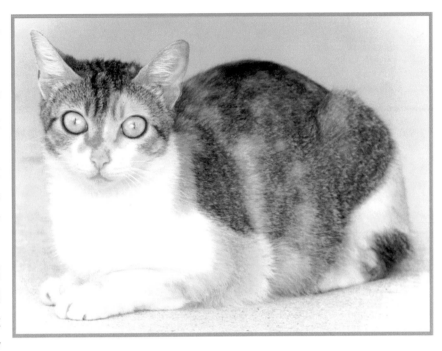

The next day, I came out, and for obvious reasons, I banged on the car, made a big deal out of leaving, so as to scare away her and the remaining kittens from the car, and then I left. When I came home, there was Chatty Catty and only ONE kitten!!! What? They're too little to go off on their own, I thought! All I know is I seemed to care more than Chatty did so I let it go and went about my day.

A few days later we were all getting used to the "new normal," ... me, one feral mommy cat, and one sweet kitten. When I left that morning I came out, banged on the car, made a big deal out of leaving so as to scare away mommy and baby from the car, and I left. When I came home, there were three kittens! Seriously? Three?! I know where kitty #5 had gone (still don't ask,) and I know that the missing three kittens are back now but ... where did Solo Kitty go?

So yesterday, I came out, banged on the hood, made a big deal out of leaving so as to clear the runway for takeoff, and when I got home Whacky Catty was standing in the driveway, alone and hissing like crazy. She was upset about something! Now I had asked her if she wanted to go with me that morning, you know ... to get a little time away from the kids and all, but she declined so that couldn't be it!

Hey ... wait a minute ... WHERE ARE THE KITTENS!

For some reason, I think this crazed maniac cat thinks I have them!!! I said, "Listen here, Chatty Batty, I don't HAVE your roaming thug kittens!" and with that, she ran past me and up under the car. Out she came with two little kittens. That's right ... TWO ... and you know what? I give up. I don't even care anymore!

#yesido #wheresmybike

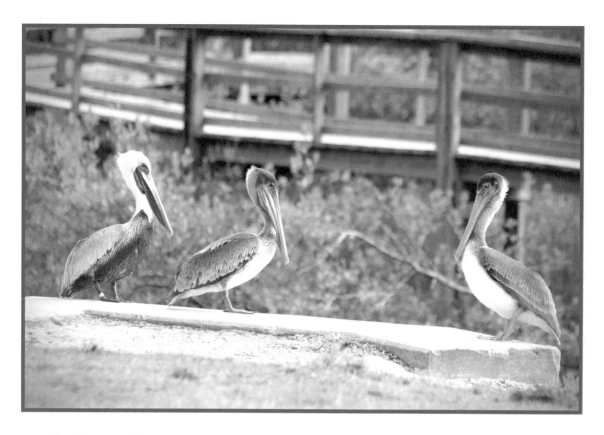

Pelican Platoon Atten-TION! Forward, MARCH!
(waddle, waddle, waddle, waddle)

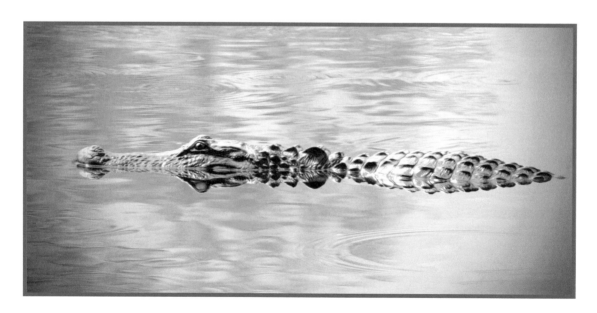

Chillin' in Chomp Chomp Swamp

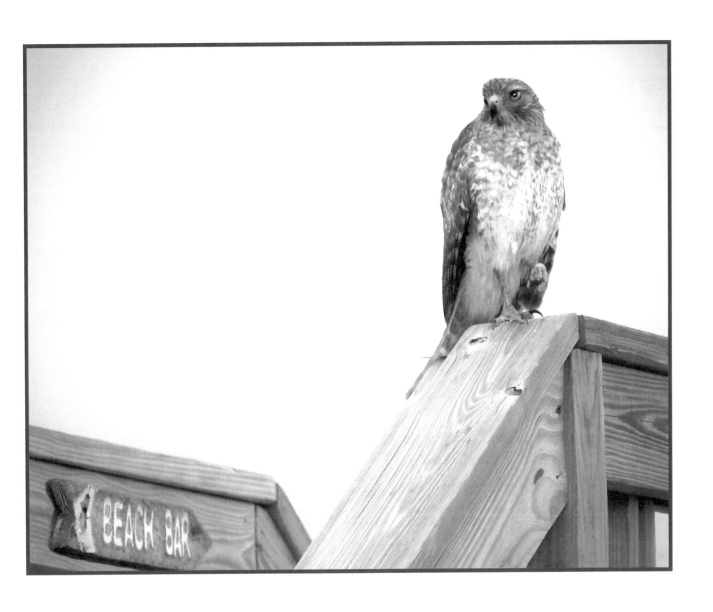

Rocko is the new bouncer
at the local Beach Bar.
He's very popular with the ladies.

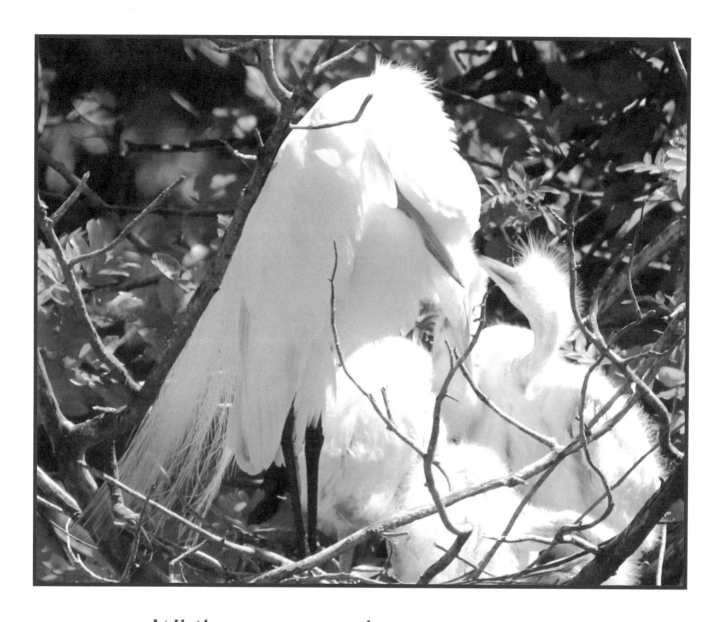

While everyone else was napping,
Mama played games with Walter.
He's not much of a napper.

#peekaboo

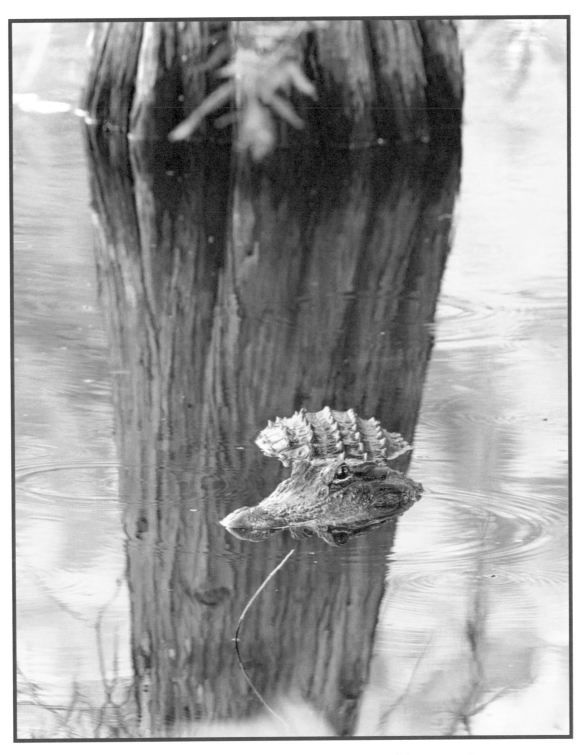

Ol' Chomp Chomp, down in Chomp Chomp Swamp
just chillin' in the reflection of a cypress tree.

#eyespywithmylittleeye

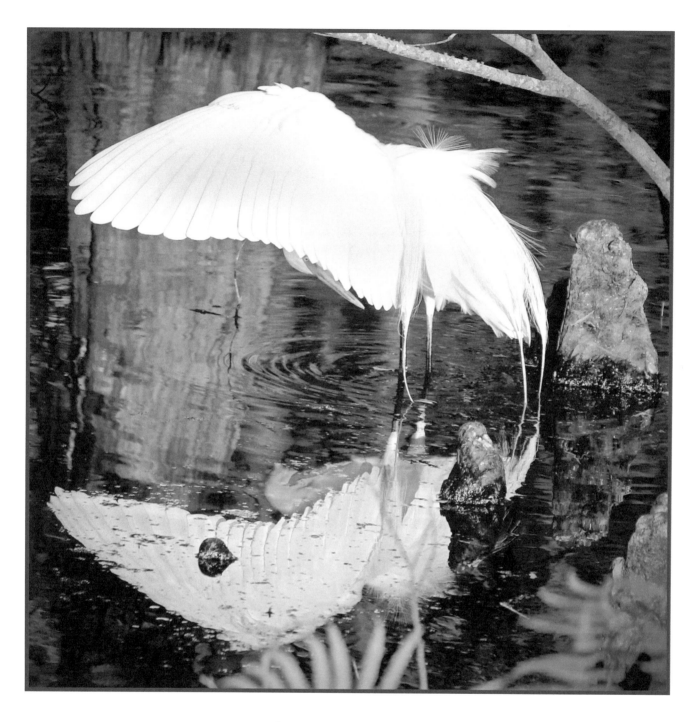

Peek-a-Boo

#reflections

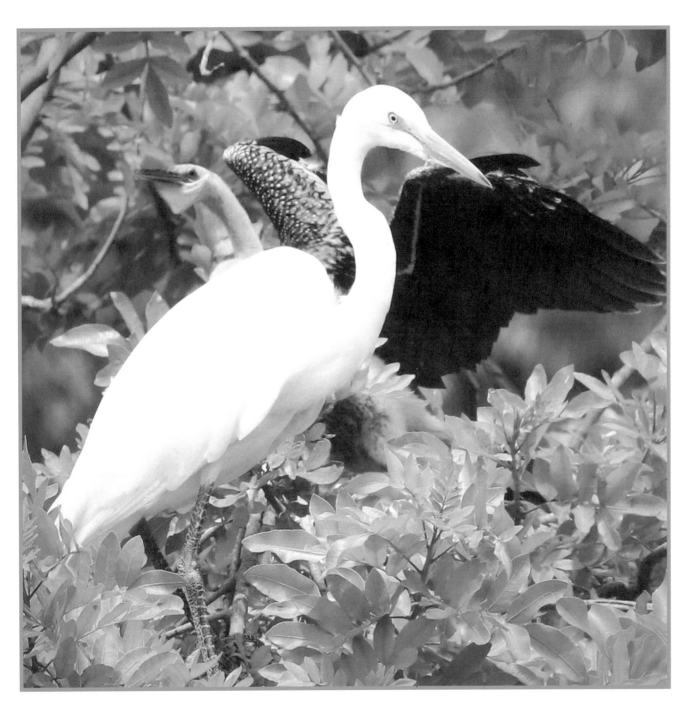

Okay, when I turn back around ...
IT * WILL * NOT * BE * THERE!
#whatISthatthing

Cyrano de Bird-gerac
(See what I did there?)

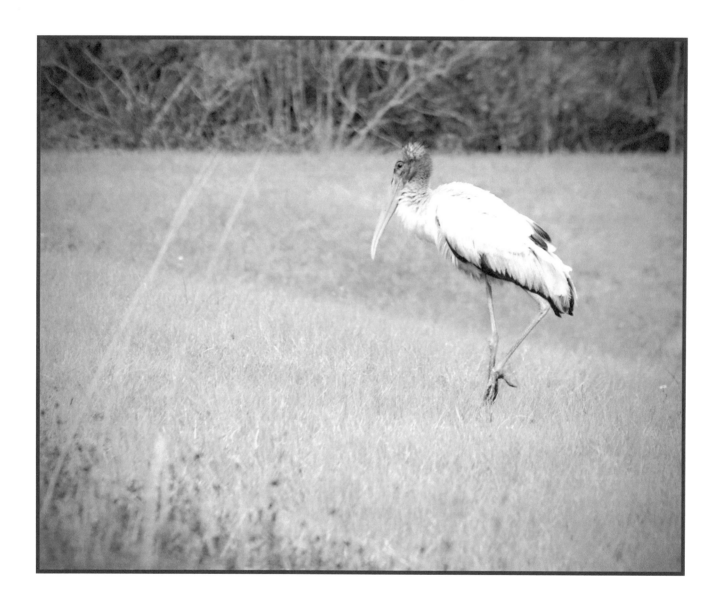

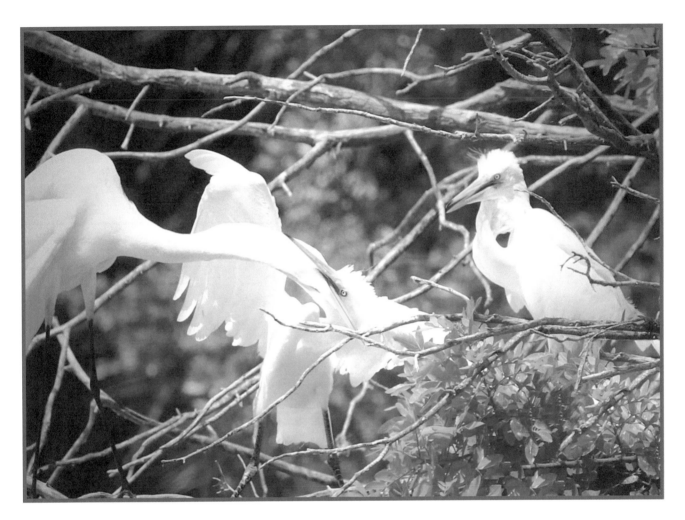

There comes a point in every young boy's life when he thinks
he's big enough to take on good ol' Dad.
Seems Archie got the jump on him but in the end, sweet
Lulu had to watch as Daddy showed her brother who was boss.

Archie Lesson #492
Never take on someone bigger than yourself unless
you have the tail feathers to back it up.

Archie Lesson #493
You will NEVER be tougher than your daddy!!!

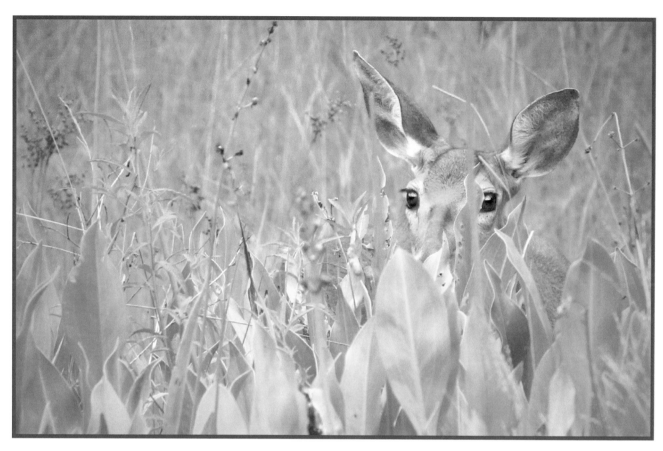

She was watching me, quietly observing my every move.
We talked for a few minutes and she started nibbling leaves again.

Come to find out, that pretty young thing was a new mother. This spotted fawn is why Mama Deer was being so guarded. They let me get a few shots off before they took off into the woods.

Another great day ...

just me n' my camera!

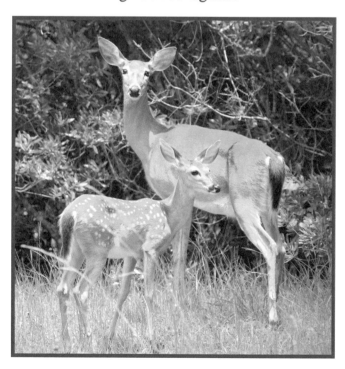

This little fella is a Grasshopper and his name is Sir Hops-a-Lot.

We met rather abruptly one day when he introduced himself to my FACE as I was getting out of the car. Luckily, we both survived the encounter, and as soon as I could breathe again and he stopped laughing at me, we spent a few minutes chatting. He's not a bad little dude, just a little jumpy when startled. I told him if he promised to never jump on my face again, I would take his picture and put it on Facebook. He agreed but only if I would tag him in it. LOL

#sirhopsalot

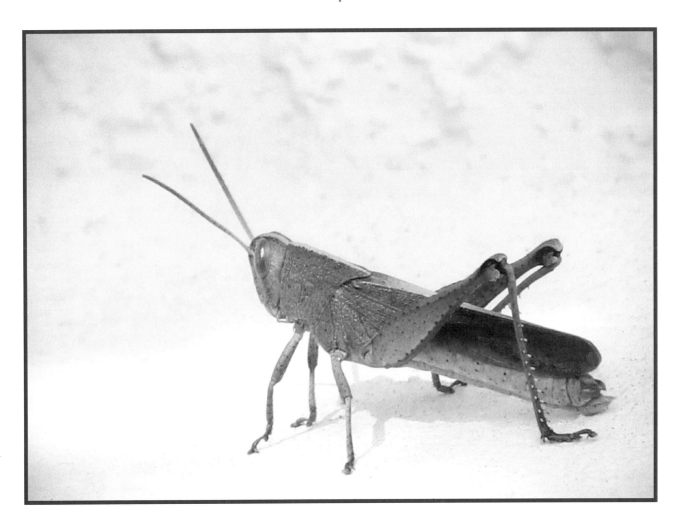

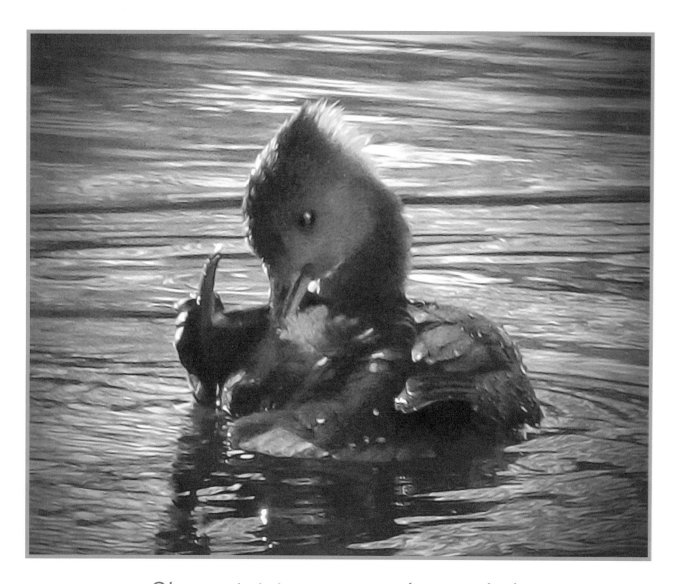

Okay, so is it just me, or is this cute little
thing giving me the feather?

#benice

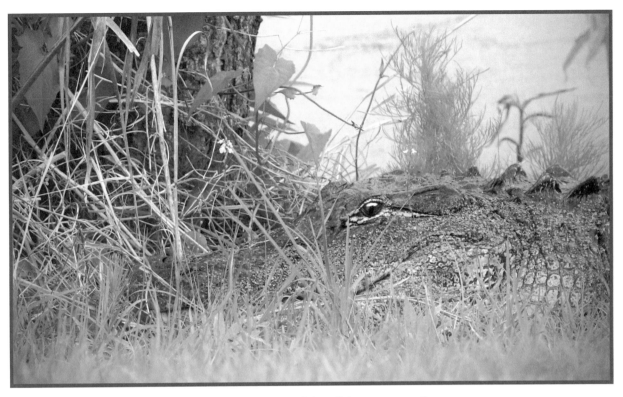

I see. you, Sir Chompus!

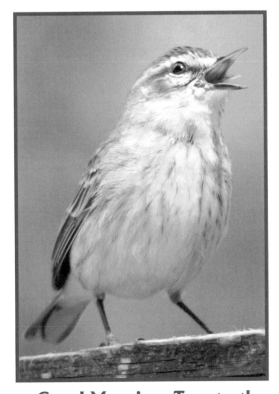

Good Morning, Tweetart!

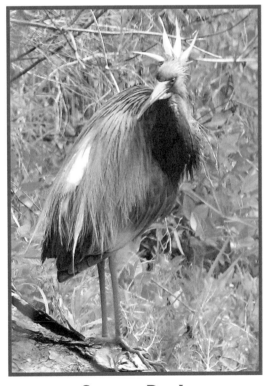

Swamp Punk

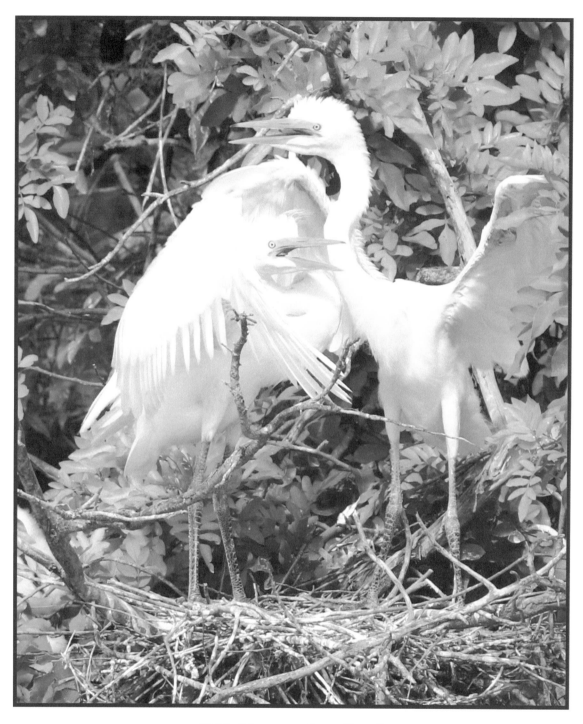

Sibling rivalry!

Huey and Louie are fighting over who gets to take Lulu to the prom.
Psst ... Walter already asked her and she accepted.

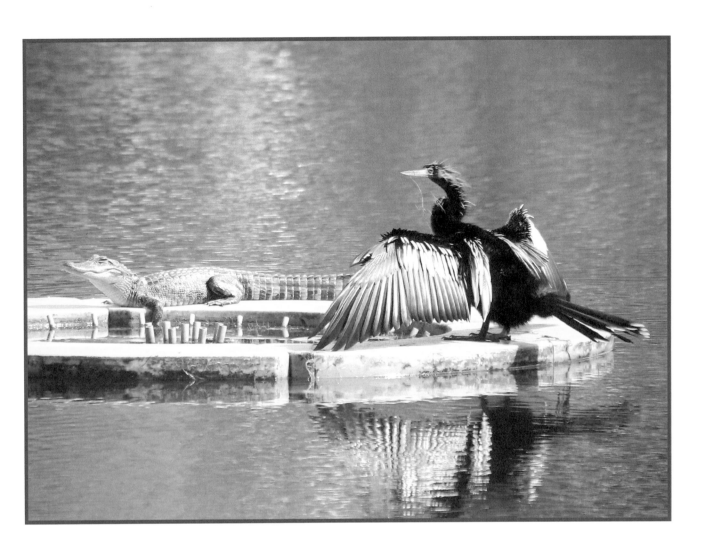

This young alligator and frazzled-looking Anhinga
are unlikely friends ... and yet, they meet up at the local
fountain to dry out and catch some rays together often.
There's also a turtle that joins them sometimes.
I guess if no one is hungry, everyone gets along just fine!
Just to be safe, I hear,
they strongly encourage social distancing.

Check out the pollen pants THIS gal is wearin'!
She's going to be a real hit back at the hive!

#pollenpantsmakemesneeze

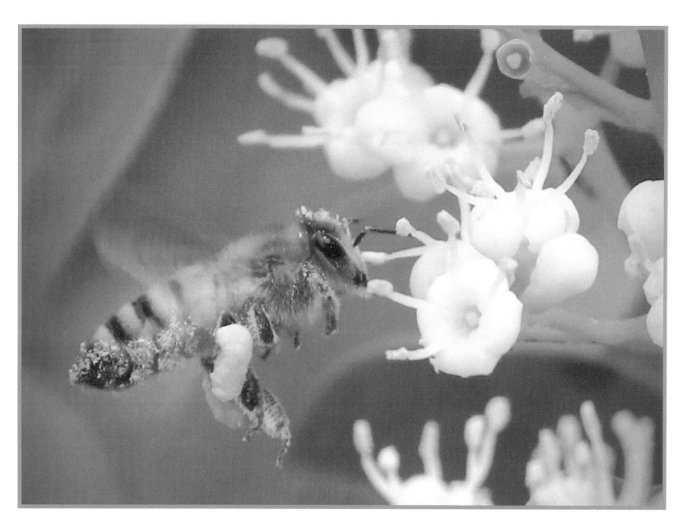

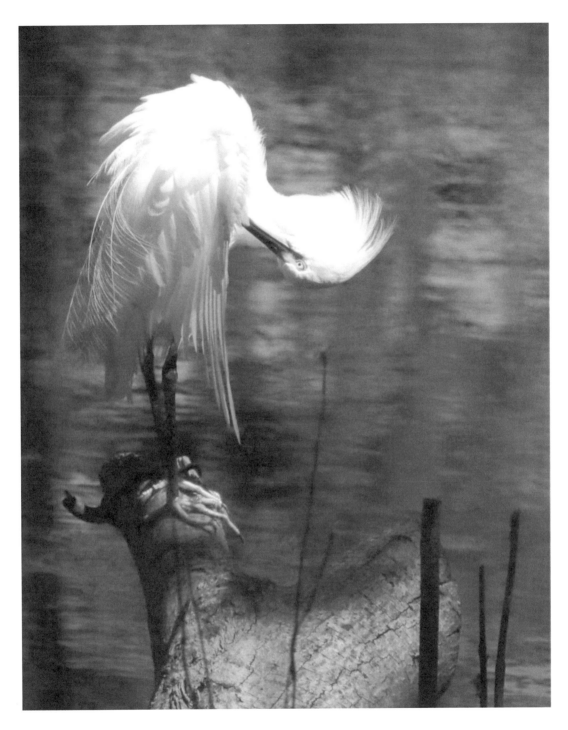

It's been raining for the last few days and I just had to get out for a bit. Seems the same was true for this Snowy Egret. She had found her own little ray of sunlight in which to preen her feathers and it made for a beautiful shot. The bright yellow skin at the top of her beak matches her bright yellow feet, which have earned the Snowy Egret the nickname of Golden Slippers.

#loveher

This was definitely one of those "being in the right place at the right time" kind of moments. It wasn't until I got home and looked at these shots on the big screen, that I realized the special moment I had been witnessing. With Mama Bird watching from above, Baby Bird was flapping around with excitement on the ground. Every once in a while she would get airborne and then plop herself back down in the leaves, make sure Mom was watching, and rest. It was like that moment when we took our first steps, the excitement that Mom and Dad felt when we took off on that first solo "flight" across the living room floor, wobbling and unsure before we dropped to the floor again, only to get up and try it again! It's awkward, it's exciting, and frantic, but it's a really big deal for all involved.

#gobabygo

Flying Lessons
It's a Busy Day For Both Mama Bird & Baby Bird

74

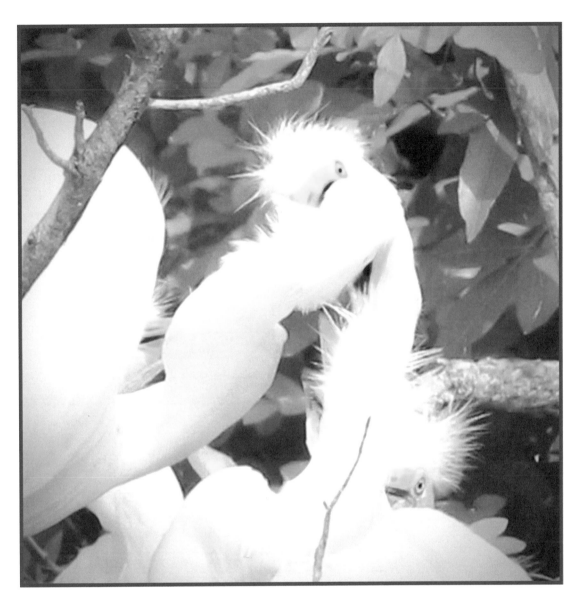

Walter?

WALTER!

Let go of Mommy's face, Walter.
That's it!
You wait 'til your father gets home!

#walterishangry

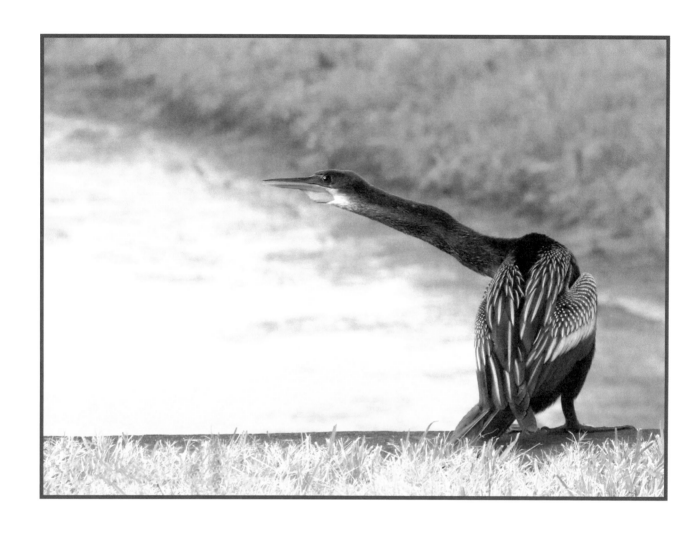

This is the Aningha, also called the Snake Bird
because it's neck can move in an "S" formation.
Every time I see it moving,
all I see is a bird with an attitude.

"Oh no you di'int!"

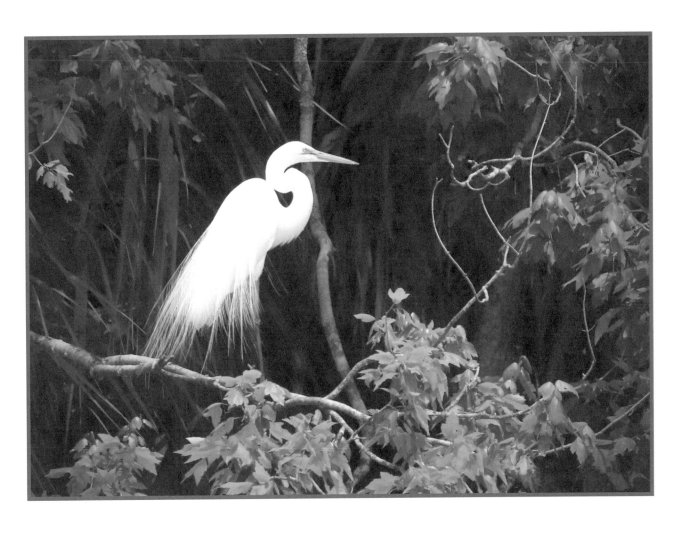

Dramatic green eyeshadow **CHECK**

Fluffed up plumes **CHECK**

Legs freshly plucked **CHECK**

Looks like the little lady is ready for some courtin'.

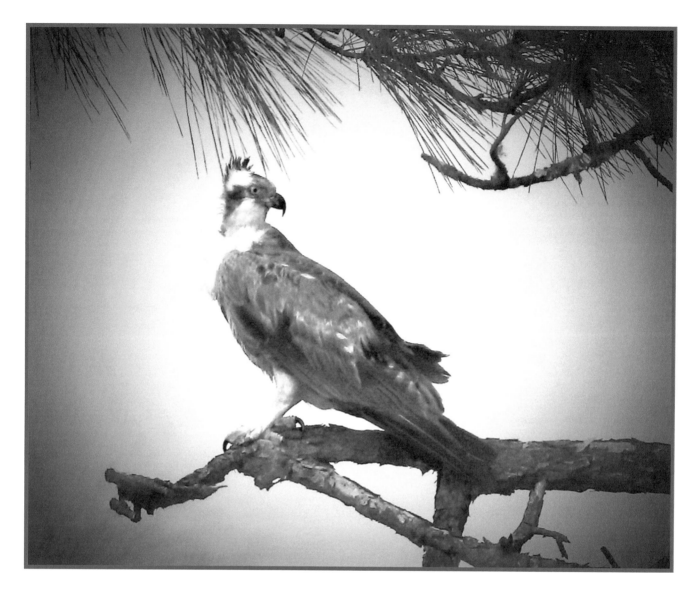

This fella is an Osprey

and I'm always mistaking him for an Eagle.

I guess it's only fair that he thought I was Bigfoot!

He had no idea why that hurt my feelings.

#@!~&*%^$

So, Ratchet asked if I liked his latest look.
He said he was going for a punk vibe with a touch of glam.
I admitted I thought he was killin' it with the Mohawk
but as much as I can appreciate a good, long and curly
eyelash, there was still one missing!

He rolled his eye and strolled away.

#moltingforthewin

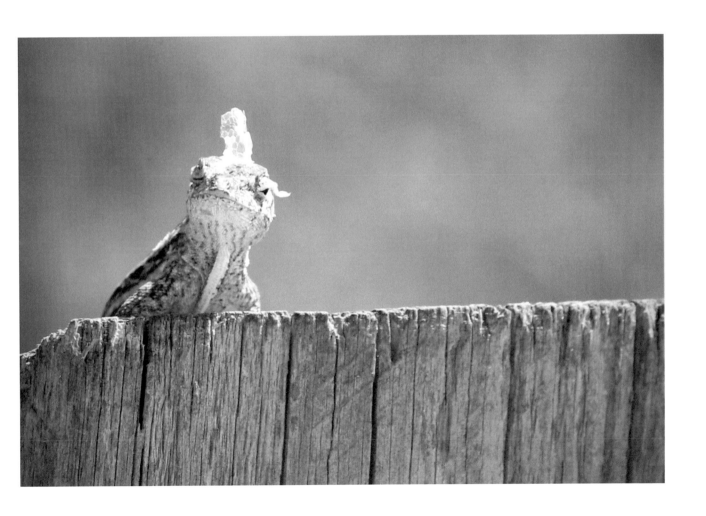

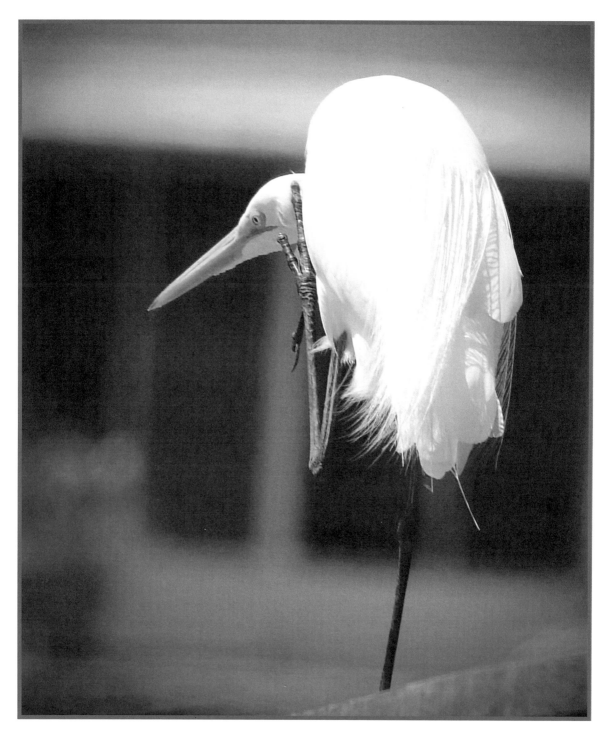

"Sophie, honey!

I told you not to call me when I'm working! Whuddaya want?"

#beakersgotladytroubles

The Belted Kingfisher is another adorable little creature that caught my attention by how pretty it was and the beautiful sounds it made. Then out of nowhere, this pretty little blue bird let out a blood curdling scream, ZOOMED out of the tree it was sitting in and flew face first, at the speed of light, into the pond we were hanging out at. Next thing I know it came back up out of the water with a fish in it's beak and flew back to the tree where it proceeded to BANG THE CRAP out of the poor little unassuming fish that never even saw him coming, I'm sure! He banged that thing around like a toddler with a pot and a lid for a few minutes and when he was convinced it would never swim again, he threw the little fella up in the air like a big pizza pie and swallowed it whole.

Remind me to never tick off a Belted Kingfisher!

#kingfisherwithangerissues

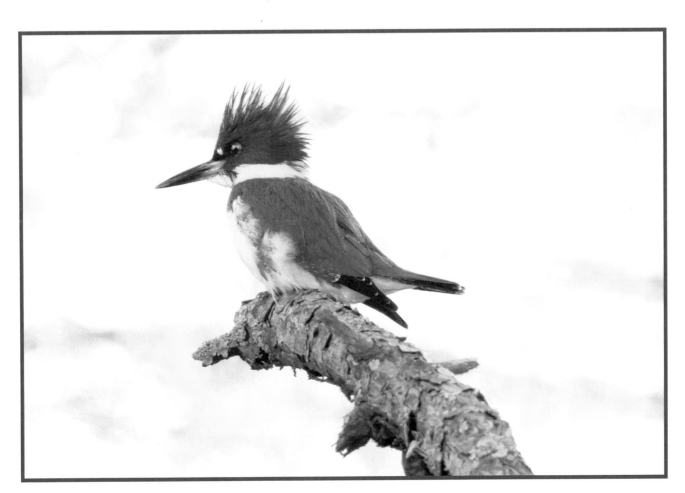

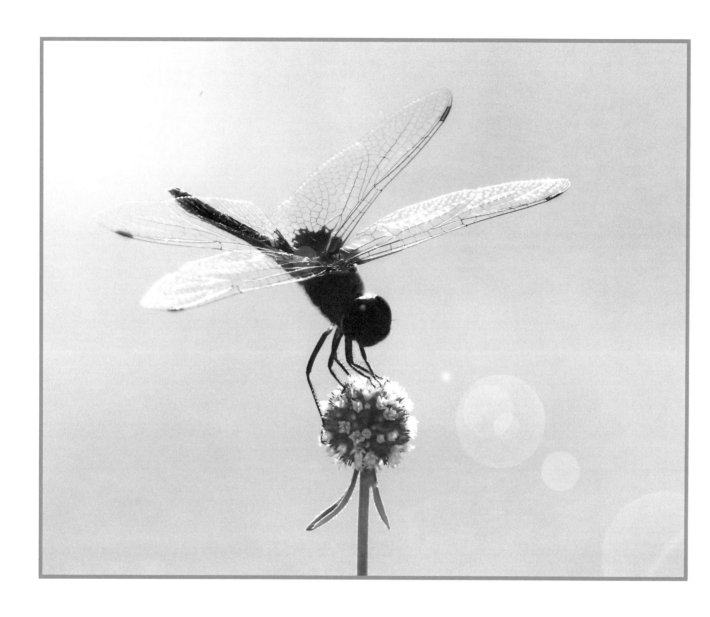

**Everyone was so happy
when Nadine caught the bride's bouquet.**

#alwaysthebridesmaidblahblahblah

In the aftermath of the pandemic and in hopes of rebuilding the brand for a whole new group of consumers, this is the 2022 Feathered Victoria Secret Fashion Show. First out on the runway is this year's newest Angel, Bella LaBeakster. Bella is draped in the latest of feathered fashions by Beaker Designs. The Angel's Wings are an annual tradition worn by only our top models.

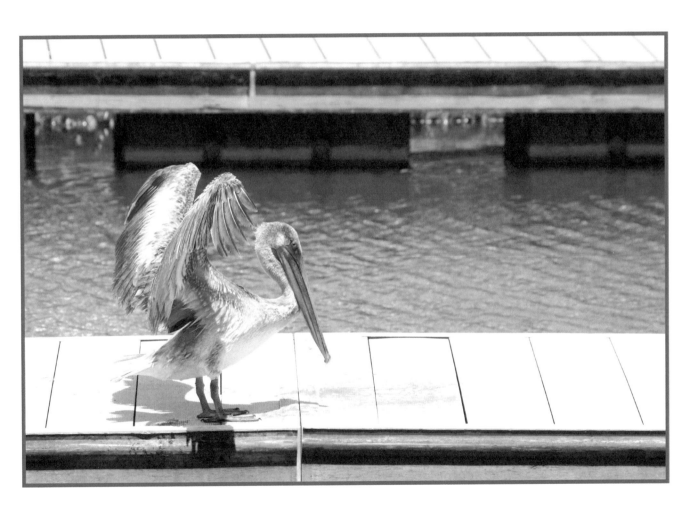

This is Ms. Labeakster's first show.
She loves children, poetry, and hopes to one day be a teacher.

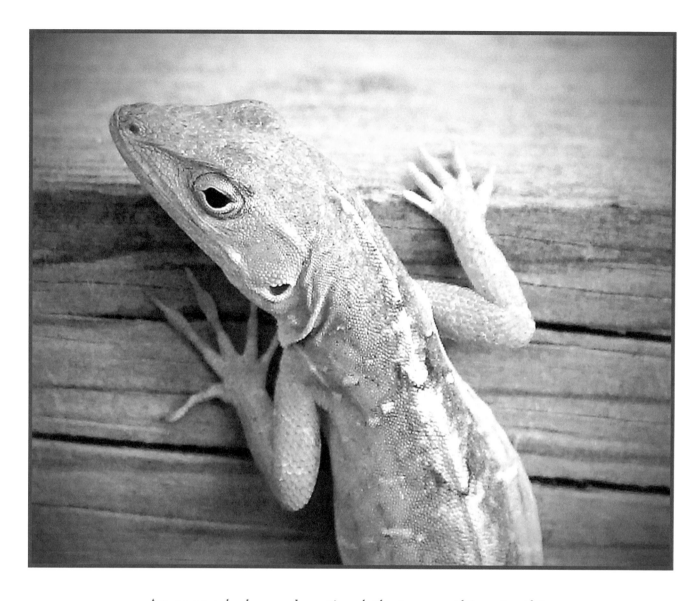

At second glance I noticed that something in this
picture was not like the other. And then I saw it ...
what the heck is up with this guy's hands?
Come to find out, Li'l Dude says that he's loving his new
prosthetic but it's gonna take some getting used to.
Seems they had a sale but were all out of hands with long fingers!

Meet FiFi ... so pretty and so dainty, right?

Well let me tell ya, this one has a mouth on her like a sailor!
I don't know what Beaker said to her but
girlfriend was madder than a wet hen!
#girlproblems

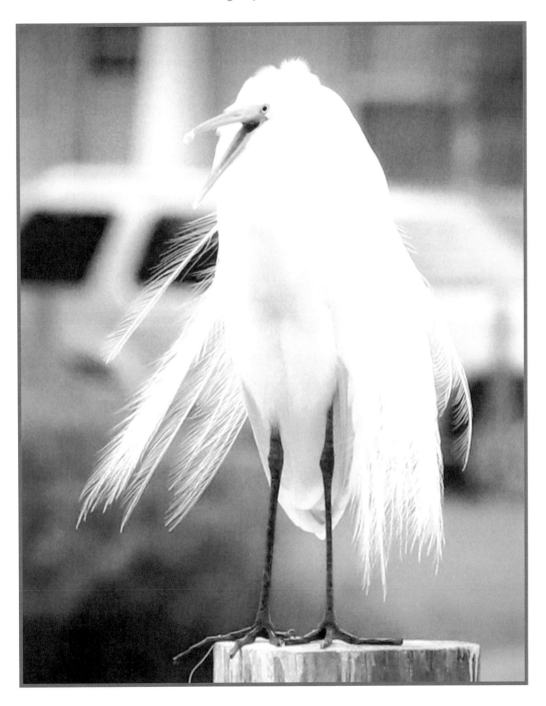

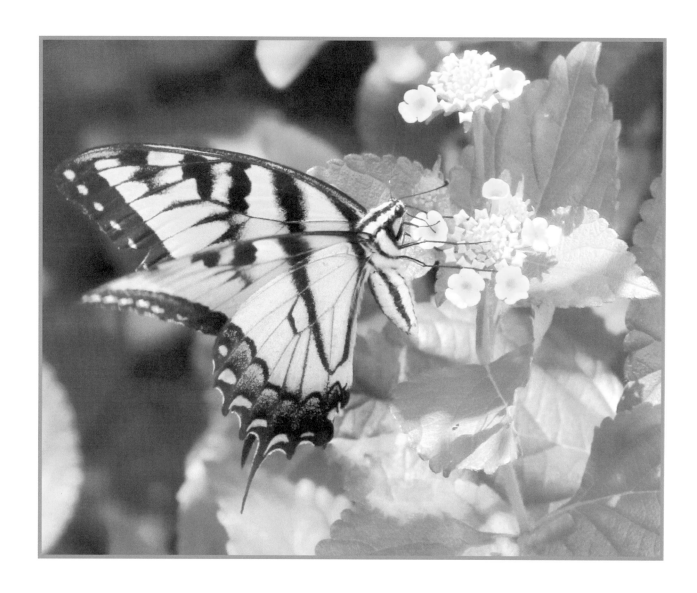

This is Ginger.

She loves the pretty smell of flowers, fluttering around in gardens, and butterfly kisses. If interested, swipe right!

#butterflysingles

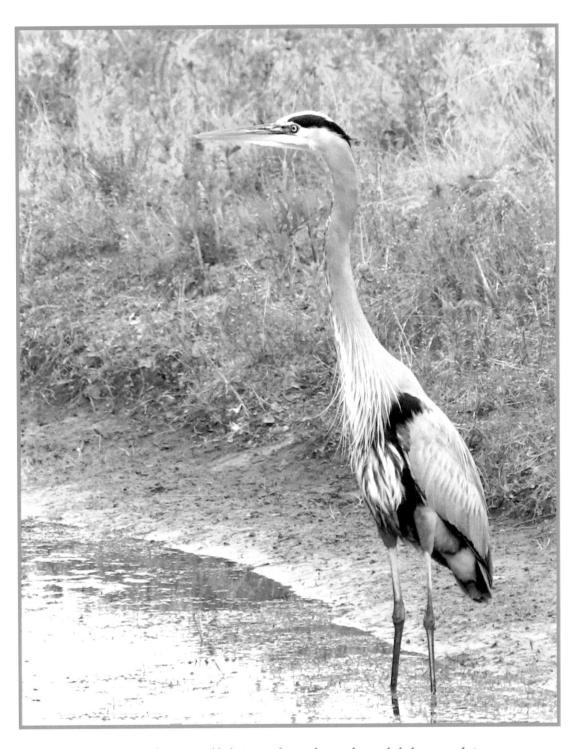

I tried to tell him that he should keep his
mechanical knees dry but he just wouldn't listen.

#creakysticks

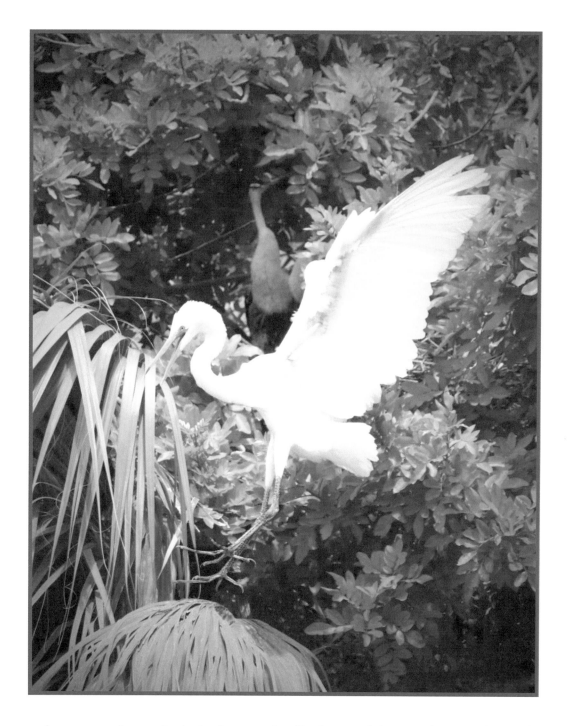

I was there to shoot Lulu's first solo flight and I got the perfect shot of
this perfect landing ... a really special day for Lulu and I got the shot!
And wouldn't you know it ...
we got photobombed by one of the Anhinga Twins!

What about Walter's first official Big Boy landing?
He flew right into the nest and right on top of his brothers!
Walter is currently on flight restriction until further notice.

#uncoolwalter

Meet Irma & Iris.

They go absolutely everywhere together.
We all had lunch together the other day and boy oh boy,
do these girls know the gossip, or what?!
Now, I always knew he was a player but word in the pond is that
<whispers> Beaker has buns in two different ovens!

#gasp

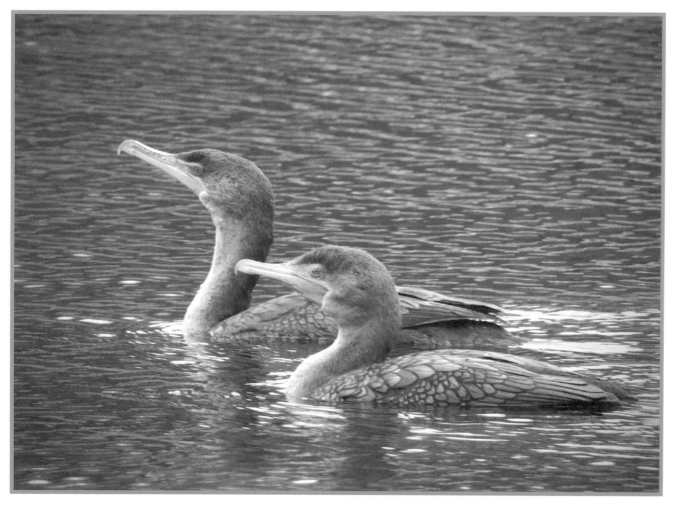

Juvenile Double Crested Cormorants.

Aren't their feather patterns amazing!

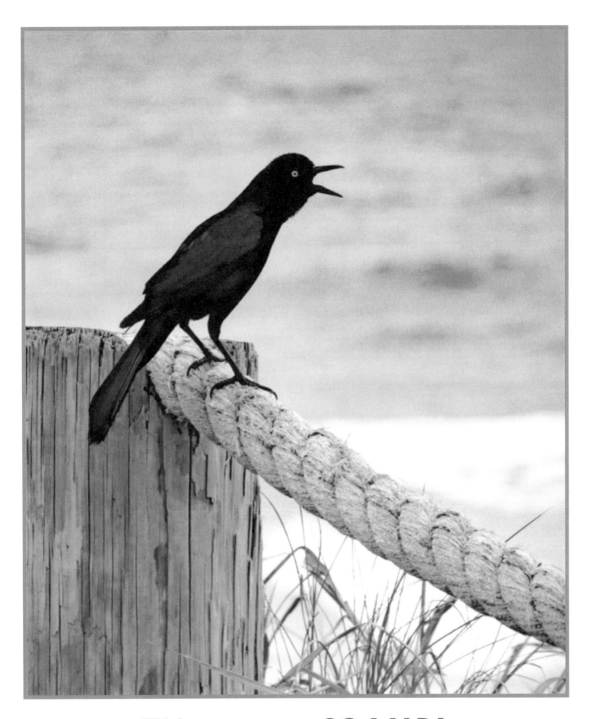

This guy was SO MAD!

I'm not sure who took his french fry
but they better watch their back!

#angrybird

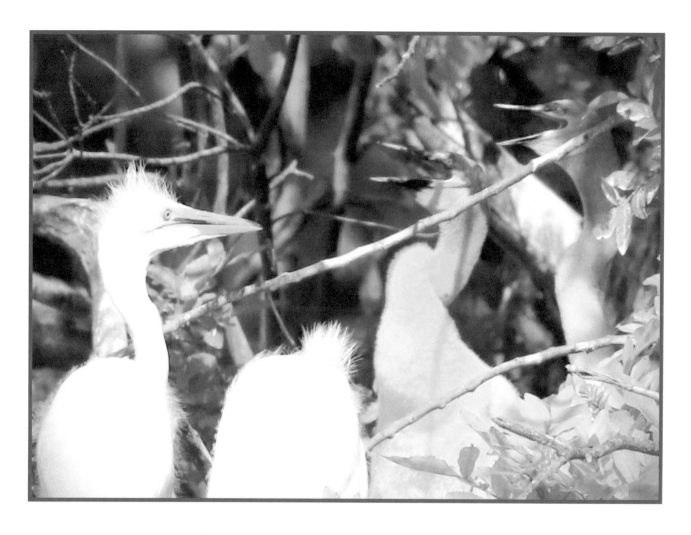

Archie whispers, "Ummm, Lulu? I don't think we're in the right tree."
(As usual, Lulu hides her head and can't look.)

Archie stared down the Anhinga twins and bravely says,

"HEY! What are YOU laughing at?"

Come to find out, the Anhingas had just never seen anyone
with all that white fluffy stuff on their heads before.

They're all going fishing together next weekend.

#itsokaytobedifferent

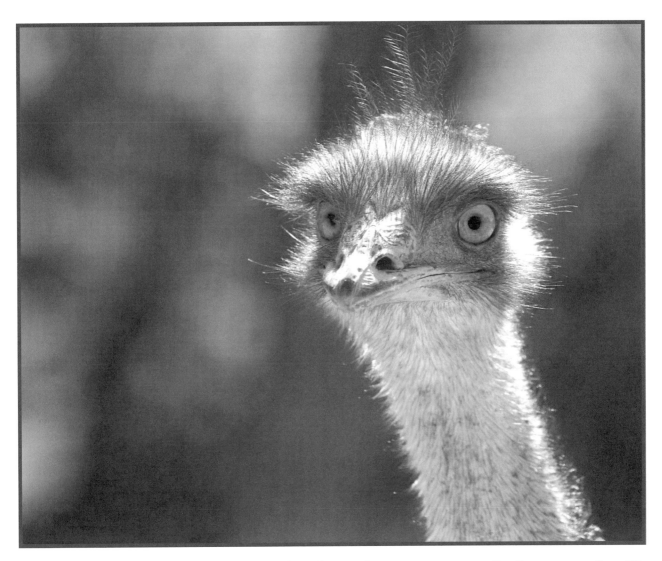

Have you ever gotten the feeling that you were being watched?

Yeah, me too, but trust me when I tell you, nothing could have prepared me for THIS guy! I was sitting on the side of the road trying to figure out where I had taken a wrong turn and I got "that feeling." I slowly turned my head and looked right into the eyes of this long-necked creature who was standing just a few feet away from my open car window!!! Turns out most of him was behind a fence but seriously, for a quick second, you couldn't convince my heart that I wasn't staring down a velociraptor straight out of Jurassic Park!!! I mean, this ostrich farm was right in the middle of a residential neighborhood. Who would have known? What the heck!? Warn a girl, why don't ya!? Anyway, turns out he was really cool and we had a lot in common. Before I left he gave me his Facebook info and can you believe ... I LOST IT!

#keyboardpecker

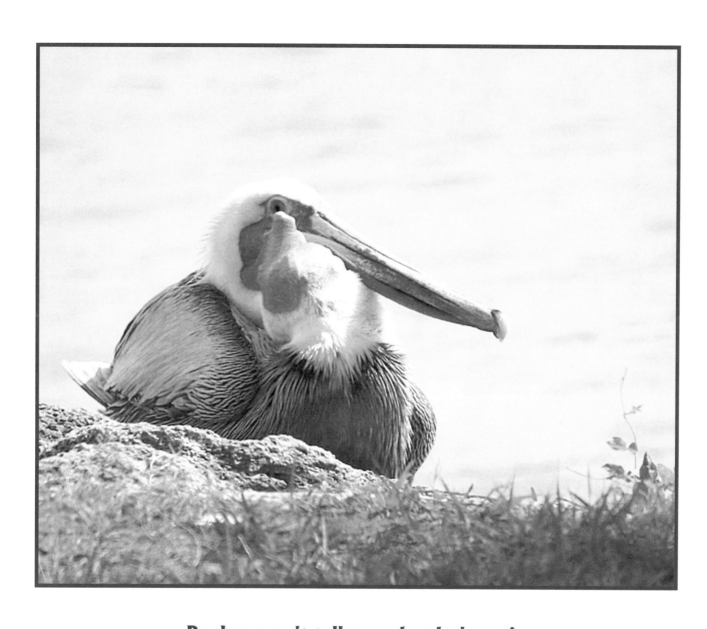

Beaker won't tell me what he's eating
but I'm pretty sure that whatever it is,
it's packin' a pistol.
I told him, "Beaker, you better spit that guy
out or he's gonna shoot his way out."

#mymoneysonhoffa

Big storms this week have wreaked havoc on my favorite tree. It's the tree that holds all the nests of the cast of characters you've met throughout this book. Most of the nests were disturbed or nearly destroyed but the babies of the season are big enough to live without them. Here you see Walter standing guard over his broken childhood home. He's waiting on the Gecko to arrive and said his family was actually very lucky because they had just added storm coverage to their policy when hurricane season began.

That's great news and Walter is thrilled! He and his new girl, Lulu, plan on raising their family there this coming Spring.

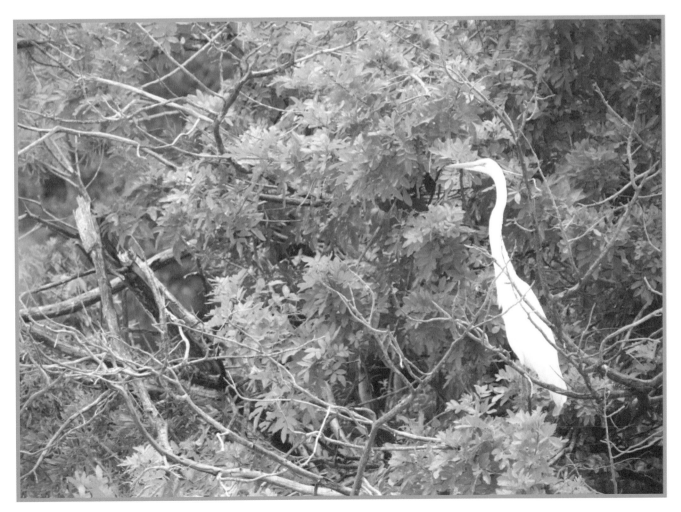

Can you pass me another baby wipe, please?

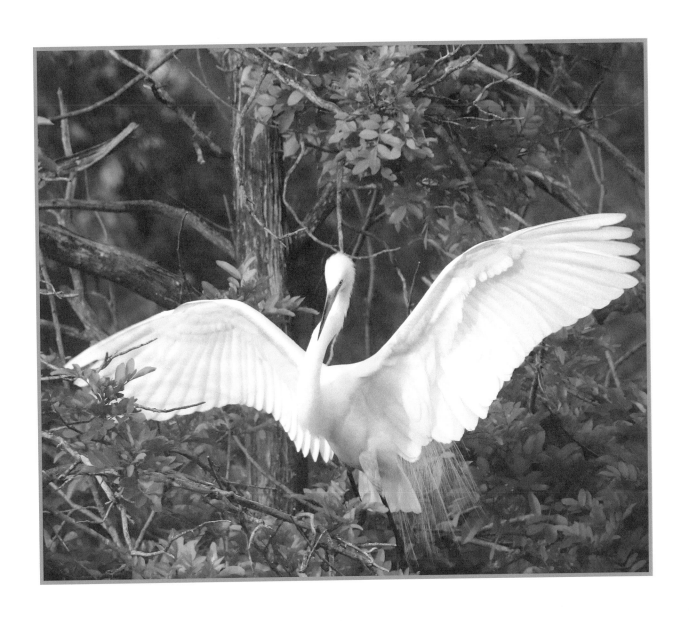

Thank you, Lord, for another beautiful day!

#amen

CPSIA information can be obtained
at www.ICGtesting.com
Printed in the USA
BVRC091222240522
637935BV00011B/600